D0853763

VERMEER OF DELFT

his life and times

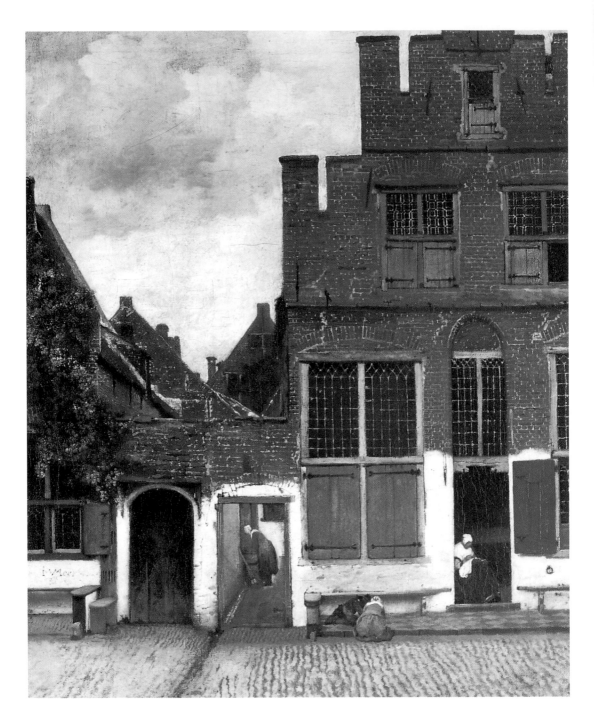

VERMEER OF DELFT

his life and times

Michel P. van Maarseveen

Translation M.E. Bennett

STEDELIJK MUSEUM HET PRINSENHOF DELFT
BEKKING PUBLISHERS AMERSFOORT

Cover: Johannes Vermeer
 The Milkmaid
 Amsterdam, Rijksmuseum

 Johannes Vermeer
 The Little Street
 Amsterdam, Rijksmuseum

Gemeente Musea Delft

Stedelijk Museum Het Prinsenhof

Prinsenhof series, deel 1

Editors: Drs. Daniëlle H.A.C. Lokin
 Drs. Michel P. van Maarseveen
 Prof. dr. Peter J.A.N. Rietbergen
 Drs. Gerdy H.J. Seegers

Printed by: Casparie Almere

© 1996 M.P. van Maarseveen
Stedelijk Museum Het Prinsenhof
Bekking Publishers Amersfoort

All rights reserved. No part of this
publication may be reproduced or
transmitted in any form including
photocopy, microfilm, television, video or
any other means without prior permission
in writing from the publisher.

ISBN 90 6109 3902 NUGI 641

Contents

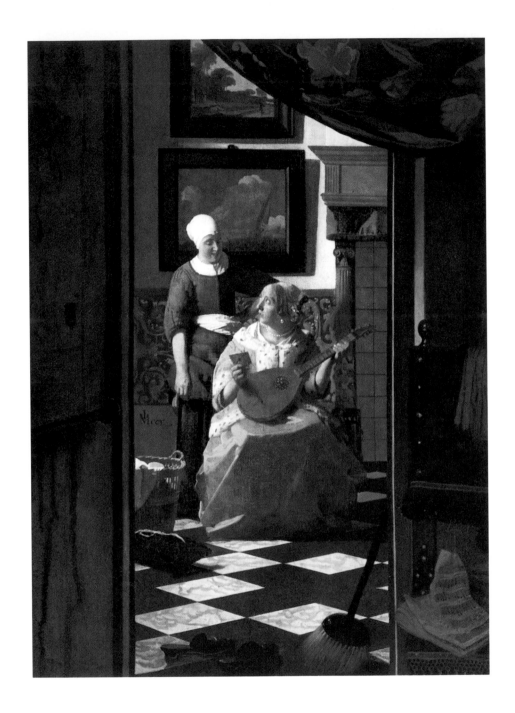

Johannes Vermeer, The Love Letter, *c. 1669-1670.*
Amsterdam, Rijksmuseum.

Preface

Ever since The Delft painter Johannes Vermeer (1632-1675) was 'rediscovered' in the nineteenth century, he has been recognized as one of the three great Dutch artists of the Golden Age. We know so much about the lives of Rembrandt van Rijn and Frans Hals, but we are in the dark as to important periods in the life of Vermeer. Nothing is known about his childhood and we can only hazard a guess in answer to the question of his apprenticeship.

We have certainly learned a great deal more about the life of Vermeer during the last ten years. Additional information was also provided by the American art historian Michael Montias thanks to his painstaking and intensive research.

In this book we have chosen to approach our subject by way of location, meaning that Vermeer's life and work will be described in relation to the places in Delft with which he was associated in some way. The many illustrations in colour take pride of place in the book. Every 'Vermeer spot' has been photographed recently and included along with reproductions of buildings as Vermeer would have seen them. The location of Vermeer's painting *"The Little Street"* is the object of a lively ongoing discussion, with all the theories being put forward and analysed in detail.

It is sad that many of these buildings have disappeared during the three and a half centuries since Vermeer's death. The inn belonging to Vermeer's father, his home, the Guildhall where he was a member of the Board, the town gates in the *"View of Delft"* were all pulled down in the nineteenth century. But the last ten years of research have yielded information on new places in Delft involved with the life of Vermeer. These include the house where he was born and the house where his father was born.

Finally I should like to thank all those who have contributed in some way to the realization of this book. In alphabetical order they are: Yves Boillot, Jos Hilkhuijsen, Michiel Kersten, Henri W. van Leeuwen, Daniëlle Lokin, Wil van Reijen, Jackie Rima, Marga Schoemaker, Joost Stokvis, Gerrit Verhoeven, Pim Westerkamp and Wim Weve.

Delft, St. Luke's Day 1995

Michel P. van Maarseveen

1 Introduction

Delft in the seventeenth century

Delft was a prosperous town in the seventeenth century with between twenty-five to thirty thousand inhabitants. The fire a century before, in 1536, had reduced a large part of the town to ashes. As a result many of the medieval wooden houses were replaced by stone buildings so that the town looked splendid in Vermeer's day. Delft was not besieged by the Spanish army during the Eighty Years War (1568-1648) as was the fate of towns like Haarlem, Alkmaar and Leiden, so it was left unscathed.

The production of textiles, beer and pottery formed the mainstay of the town's economy. When the textile industry dwindled at the

end of the sixteenth century, Delft town council took measures in an effort to save the industry. The council offered favorable terms of establishment and put workshops at the disposal of carpet weavers and cloth manufacturors in the hope that they would settle in Delft. At first these efforts were successful, but they could not persuade the textile producers to stay permanently. By the mid-seventeenth century there were only a few small textile firms left in Delft. The large companies had disappeared in the meantime.

There were many breweries in Delft in the Middle-Ages. The export of beer to the Southern Netherlands declined as the number of breweries there rose, and the steady increase in the price of raw materials caused many of the Delft breweries to go out of business during the sixteenth century. This was partly because Delft had specialized in brewing ship's beer, but many seaports began to brew their own beer as a result of the rapid growth of shipping. In spite of these developments the production

Anonymous, Town plan of Delft after the fire of 1536.
Delft, Stedelijk Museum Het Prinsenhof.
A great fire reduced large parts of Delft to ashes on 3rd May 1536. Over two hundred houses were destroyed.

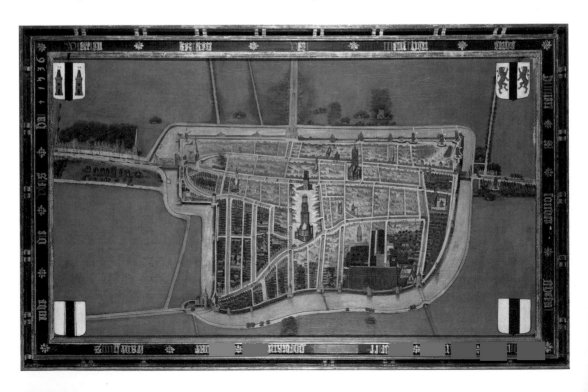

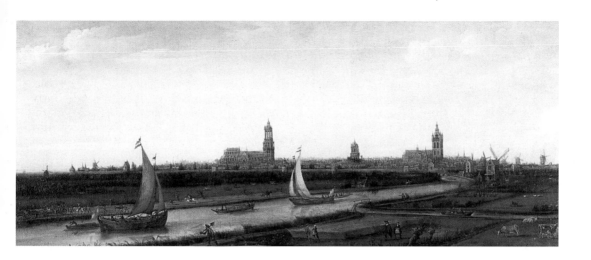

Hendrick Vroom, View of Delft from the north, *c. 1615.*
Delft, Stedelijk Museum Het Prinsenhof.
Vroom's view of the town reveals the prosperity of Delft. The busy Vliet waterway in the foreground and the profile of Delft visible behind it with the towers of the Nieuwe Kerk, the town hall and the Oude kerk.

of beer in Delft was still an important factor in the local economy at the beginning of the seventeenth century. However, the Delft breweries dwindled away in the course of the seventeenth century.

In contrast the pottery industry was flourishing. The import of Chinese porcelain by the Dutch East India Company came to a halt in the middle of the century as a result of a civil war in China. This meant golden days for the Delftware factories. More and more companies were set up between 1650 and 1680, specializing in the production of Delftware. A quarter of the population was already dependent on this branch of industry for a living. Delftware can be seen in many of Vermeer's paintings. The most spectacular example is the white jug made of plain white Delftware.
Various factors combined to make Delft the centre of the pottery industry at this time. Clay suitable for the manufacture of delicate pottery was obtained from the west bank of the river Schie nearby. Delft was a long-established production centre for pottery and, unlike their colleagues elsewhere, the Delftware potters had learned to adapt their production methods to changing demands. Delftware made between 1650 and 1680 was mainly of the so-called Chinoiserie, made in imitation of Chinese porcelain with oriental patterns.
The foundation of its own East India Company-Chamber at the beginning of the seventeenth century was important to the economy of Delft. The influence of the Company was noticeable in many fields. It was the largest employer in the Province of Holland. All kinds of workmen were needed to build and fit-out the ships, from carpenters to dock-hands for the cargo. They were dependent on the EIC for their livelihood. When a ship set off on a voyage, enormous quantities of food, beer and other necessities were bought from the local purveyors. The EIC bought most of their merchandise.
The presence of a number of immigrants from the Southern Provinces, who had fled to the north at the end of the sixteenth and

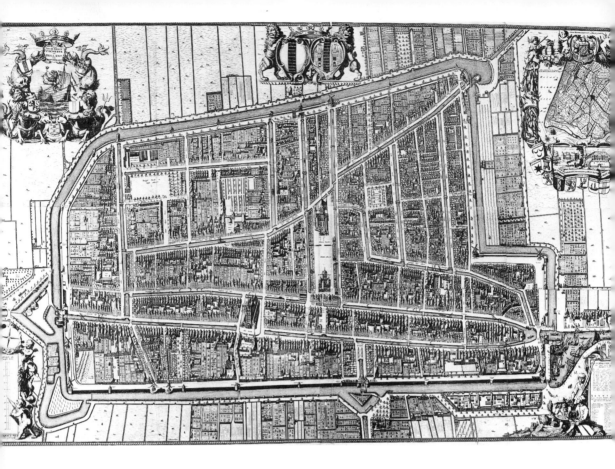

Johannes de Ram, Figurative Map, *1675-1678.*
Delft record office.
This town plan of Delft was made by order of the
town council between 1675 and 1678. It was
compiled by the town historian, Dirk van
Bleyswijck. The Figurative Map *was a prestige*
object for Delft to show that it was as good as
the other towns of Holland.

beginning of the seventeenth centuries for
economic or religious reasons, also had a
great influence on everyday life in the town.
Vermeer's grandfather on his mother's side,
who was born in Antwerp about 1573, was
one of these. Although there was little
immigration in Delft in comparison with
other towns, there were still many skilled
craftsmen who settled in Delft, from
Antwerp, Bruges, Mechlin and Ghent. The
wool industry was introduced to Delft by
immigrants and the carpet industry too,
which flourished in Delft during the
seventeenth century thanks to southern
incentives.

The Delft thunderclap

One spectacular occurrence in seventeenth-century Delft was the gunpowder disaster. At 10.30 in the morning on Monday 12th October 1654 the population of Delft was startled by a thunderous explosion which reduced the northeast of the town to ruins. The explosion, which went down in history as the Delft Thunderclap, was caused by an explosion in the powder magazine of the States of Holland and West Friesland. There were some ninety thousand pounds of gunpowder stored there at the time of the explosion.

The damage was colossal. Countless buildings for miles around were heavily damaged or destroyed. Two hundred houses completely disappeared. On the spot

Daniel Vosmaer, Delft after the Powder explosion of 1654
Delft, Stedelijk Museum Het Prinsenhof.
Vosmaer painted the scene in Delft soon after the explosion of the powder magazine on 12th October 1654. Many houses were badly damaged. A crater filled with mud formed on the site of the magazine, in the right of the painting.

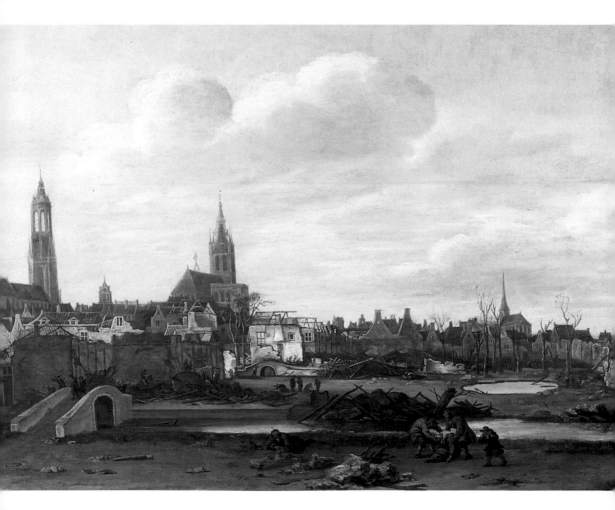

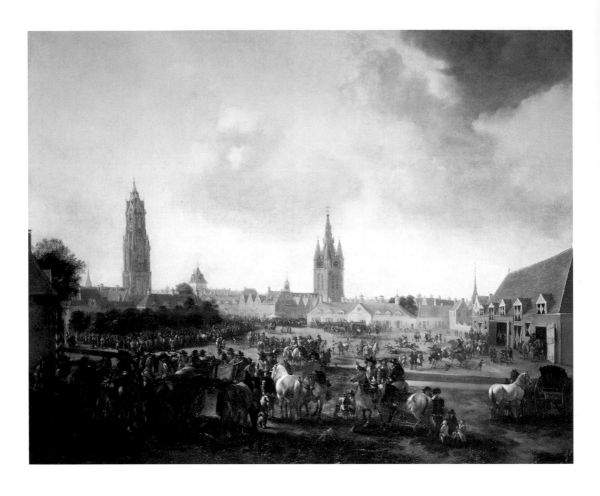

Pieter Wouwermans, View of the Horsefair at Delft, *1665*
Delft, Stedelijk Museum het Prinsenhof.
Eleven years after the explosion of the powder magazine, Pieter Wouwermans painted the site of the disaster. A horsefair was in progress on the site where the powder magazine once stood. All traces of the explosion had disappeared in the meantime.

where the powder magazine once stood there was a crater five metres deep and full of mud. The number of dead is uncertain. Estimates range from a hundred to about a thousand people. Many of the dead left no trace at all.

The best-known victim of the gunpowder disaster was the artist Carel Fabritius. According to the Delft historian Dirck van Bleyswijck he was in his studio, working on a portrait of Simon Decker, the verger of the Oude Kerk, at the time of the explosion. He was buried under the rubble and could not be freed until about seven hours afterwards. Grievously wounded, Fabritius was taken to the Oude Gasthuis hospital where he died a

quarter of an hour later. He was buried on the same day with fifteen other victims, Simon Decker among them, in the Oude Kerk.

The gunpowder disaster has been painted many times, by Egbert van der Poel and Daniel Vosmaer among others. The pictures show the devastation caused by the explosion. The artists co-operated closely. Van der Poel painted the figures on some of the paintings by Vosmaer.

However far-reaching the effects of the disaster were on Delft, the town did not take long to recover from the destruction. A painting by Pieter Wouwermans made eleven years after the Thunderclap, depicts a festive horsefair held on the site of the explosion with no reminders of the disaster at all.

Delft as artistic centre

Painting in Delft at the beginning of the seventeenth century was fairly mediocre. There were some artists in the town portraying biblical and mythological subjects. One of these artists was Leonaert Bramer (1596-1674) whose work stands out with a fluent and animated style and experiments with light. The art of portraiture on the other hand reached a high level in Delft. The most important painter in this genre was Michiel Jansz. van Mierevelt (1567-1641). He was usually commissioned to portray wealthy burghers of Delft and nobles from the stadholder's court circle. The demand for portraits was so great that Van Mierevelt employed several apprentices who copied his work. There is a notable series of state portraits of the stadholders of Holland and Friesland, commissioned by the town council of Delft in 1620. Van Mierevelt's portraits are outstanding for their subtle and accurate portrayal of the face, reflecting the distinguished status of the subject with a stately charisma. His style was continued by Jacob II Willemsz. Delff and Willem van Vliet. Still-life painting in

Delft was also popular with the artists Pieter Cornelisz. van Rijk, Balthasar van der Ast and Harmen Steenwijk. Painters in Delft were producing still-life pictures during the whole of the seventeenth century.

There were some big changes in painting at Delft during the 1640s. Several well-known artists settled at Delft at this time. They included the cattle painter Paulus Potter, the specialists in church interiors Gerard Houckgeest and Emanuel de Witte, the folk artist Jan Steen, Rembrandt's apprentice Carel Fabritius and Pieter de Hooch, who

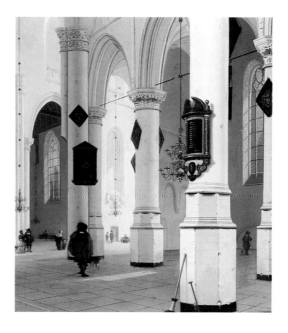

Hendrick van Vliet, Interior of the Nieuwe Kerk.
Delft, Stedelijk Museum Het Prinsenhof.
Many church interiors were painted in Delft in the mid-seventeenth century. One of the artists to depict them was Hendrick van Vliet of Delft. This painting of the Nieuwe Kerk has some architectural elements which were borrowed from the Oude kerk.

painted interiors. Most of these artists only worked here for a short time, but their presence was a great incentive to local painting where new genres were taken up, including interiors, townscapes and church interiors. The Delft artist Hendrick van Vliet also painted church interiors, in addition to the two artists mentioned above. They often chose the Oude or Nieuwe Kerk interiors as their subject. Their outstanding features include strong diagonals and the use of unexpected points of view. People are often portrayed in the interiors of churches in a perfectly natural way. The development of the townscape and Pieter de Hooch's paintings of interiors will be described in a later chapter.

These new developments were at their height in the early 1650s. The artistic level dropped again soon after 1660 when many of these influential painters had left for Amsterdam, or like Fabritious, they had died.

The only great master to stay in Delft was Johannes Vermeer (1632-1675).

Johannes Vermeer, Diana and her Companions, *c. 1655-1656.*
The Hague, Mauritshuis.

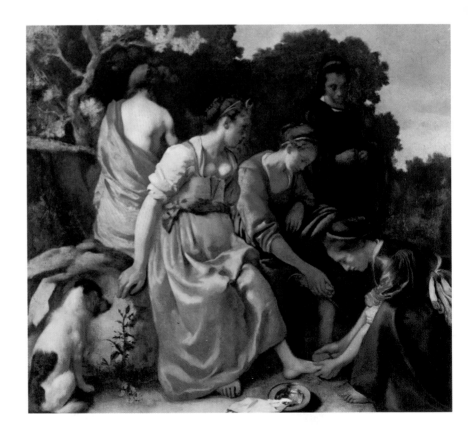

The development and meaning of Vermeer's painting

It is no easy matter to outline the development of Vermeer's work as only three of his paintings are dated.
A reconstruction of his stylistic development can be made based on those works and by comparison with paintings by contemporaries.
Vermeer's earliest works depict a scene from the bible and a mythological subject. While the painting *Christ in the house of Mary and Martha* was being cleaned in 1901, Vermeer's signature appeared. Earlier on, during restoration of *Diana resting with her*

Johannes Vermeer, The Matchmaker, *1656. Dresden, Staatliche Kunstsammlungen Gemäldegalerie, Alte Meister.*

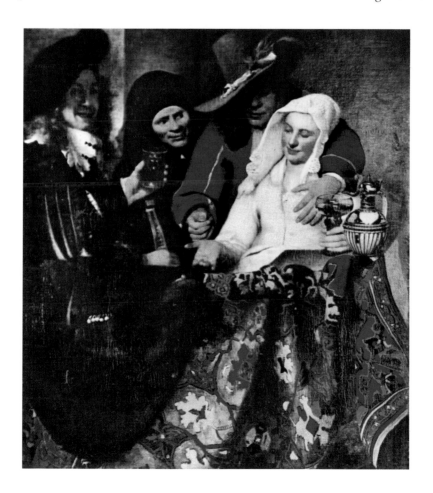

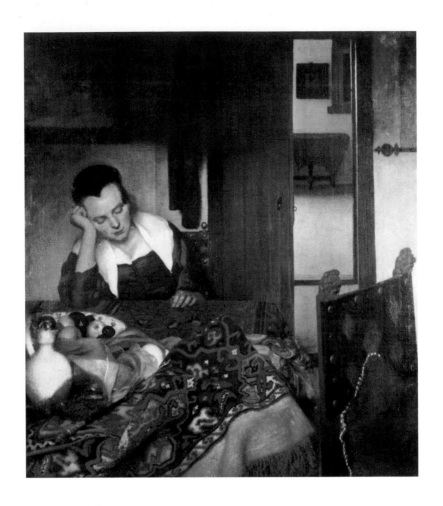

Johannes Vermeer, A Girl Asleep, *c. 1657.*
New York, The Metropolitan Museum of Art.

companions in the Mauritshuis, the letters
'J Meer' were discovered. These two finds
threw new light on the work of Vermeer
who, it seems painted very different subjects
at the start of his career, from those in his
later work. A strong Italian influence is to be
seen in both paintings. There is no evidence
that Vermeer was ever in Italy. He may well
have come to know southern painting
through the Italian paintings imported
during the seventeenth century and the
Dutch followers of Italianate art, the
Amsterdam history painters and the Utrecht
Caravaggisti. He was on good terms with
Leonaert Bramer (1596-1674) who spent

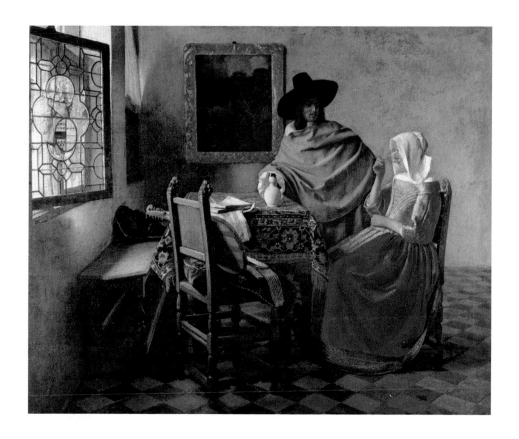

some time in Italy and this contact may also have introduced him to that style of painting.

Vermeer must have been familiar with the work of Italian painters as he assessed the value of a number of paintings, believed to be Roman and Venetian, which the Brandenburg Elector wanted to buy for a huge sum in 1671. Warned against this by his advisor Hendrik de Formanteau, the Elector decided not to buy. But the art dealer refused to take the paintings back. Fortmanteau then called in experts, to demonstrate that the works were forgeries or copies. Vermeer was probably approached because he also dealt in the paintings of other artists. Together with the artist Hans Jordaens he appeared before a notary at The Hague and declared

Johannes Vermeer, The Glass of Wine, *c. 1660-1661.*
Berlin, Staatliche Museen zu Berlin, Gemäldegalerie.

the works to be a "load of trash" not worth even a tenth of the price asked.

Vermeer's work went through a period of transition between 1656 and 1658. The painting *The Matchmaker* forms the link between the classical and mythological subjects and the contemporary scenes which he painted from then onwards. This painting still shows Vermeer's early monumental style, while revealing a new phase in his work by the choice of subject. Influenced by Pieter de Hooch (1629-1684) Vermeer began to concentrate on painting interiors during this period, emphasizing

Johannes Vermeer, Young Woman with a Waterjug, *c. 1664-1665.*
New York, The Metropolitan Museum of Art.

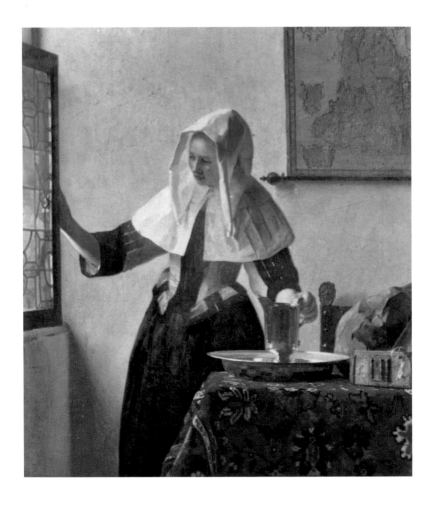

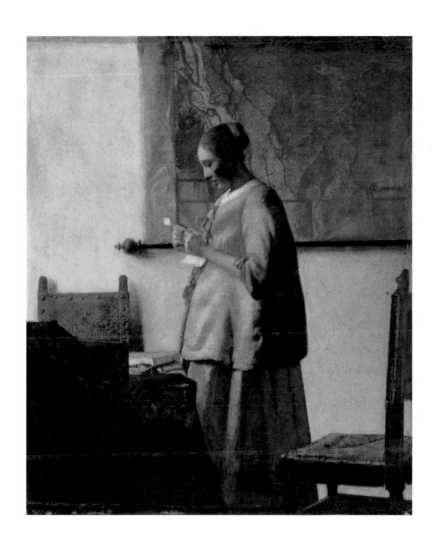

Johannes Vermeer, Woman in Blue Reading a Letter, *c. 1663-1664. Amsterdam, Rijksmuseum.*

the incidence of light and perspective. In comparison with the work of De Hooch, Vermeer simplified his paintings by concentrating on a few objects which he portrayed, paying special attention to the play of sunlight in a room. This development was first seen in the painting *A Girl Asleep* and it was later perfected in *The Girl with the Wineglass*. He painted two townscapes in about 1660: *View of Delft* and *The Little Street*. These paintings follow developments in Delft painting in the mid-

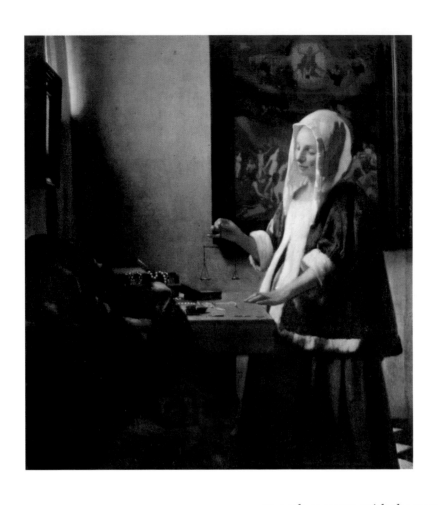

Johannes Vermeer, A Woman holding
a Balance, *c. 1664.*
Washington, National Gallery of Art, Widener
Collection.

seventeenth century, with the perspectival
depiction of buildings and the naturalistic
painting of light as the main features.
Vermeer painted robustly in this period,
applying his paint lavishly, particularly in
the light areas. The figures are boldly
modelled, for instance in *The Milkmaid*.
His work began to show refinement and a
subtler portrayal of objects from about 1662,
as in *Young Woman with a Water Jug*.
Influenced by the work of the Leiden artist
Frans van Mieris, this tendency was
continued in three small paintings of women
standing before a table by the window:
Woman in Blue Reading a Letter,
A Woman Holding a Balance and *Woman with*

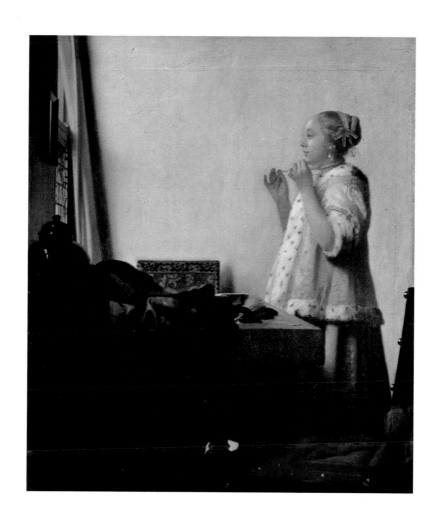

Johannes Vermeer, Woman with a Pearl
Necklace, *c. 1664.*
*Berlin, Gemäldegalerie Staatliche Museen zu
Berlin.*

a Pearl Necklace. Vermeer also painted people
making music during this period including
The Concert. In contrast with his earlier
interior paintings the figures are placed in
the background and the foreground is
dominated by a heavy table.
The Allegory of Painting which he painted
about 1666/67, forms an absolute climax in
Vermeer's oeuvre. In this work he flawlessly
combined detailed reproduction with a
sublime dimensional picture. Vermeer chose
to simplify his paintings after *The Allegory of
Painting.* The delicate transitions between
areas of colour and the subtle depiction of

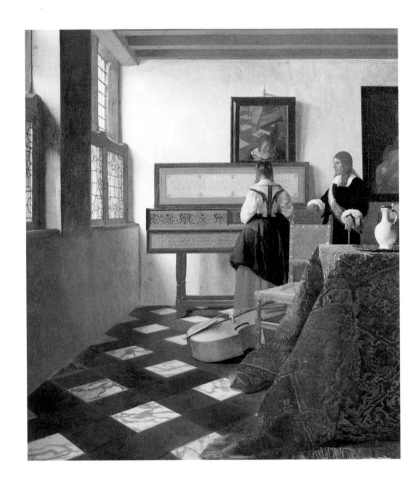

details disappeared from his work to be replaced by greater abstraction in the depiction of objects and a clear distinction between light and darker areas. This can be seen in *The Love Letter* in the Rijksmuseum and *Mistress and Maid* in the Frick Collection in New York.

Two outstanding paintings in Vermeer's oeuvre are *The Astronomer* (1668) and *The Geographer* (1669) which, together with *The Matchmaker* (1656) are his only works that are dated. In these two works Vermeer still paints in his refined style of the early 1660s while at the same time introducing austerity, for instance in the background.

Johannes Vermeer, The Music Lesson, *c. 1662-1664.*
London, Buckingham Palace.

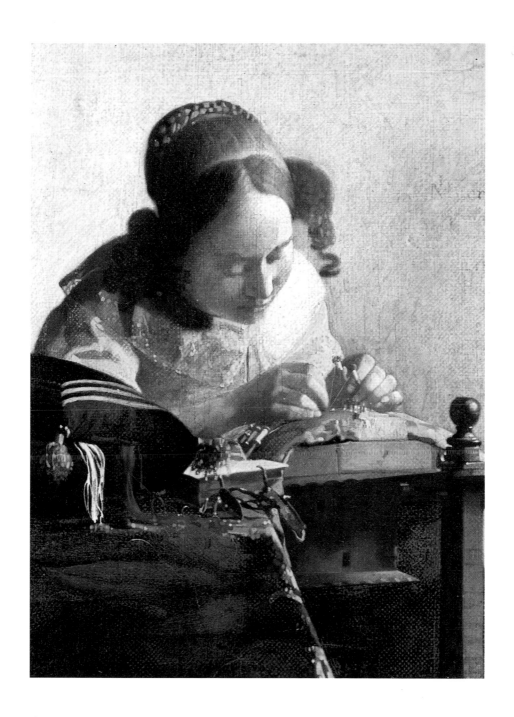

Johannes Vermeer, The Lacemaker, *c. 1669-1670.*
Paris, The Louvre.

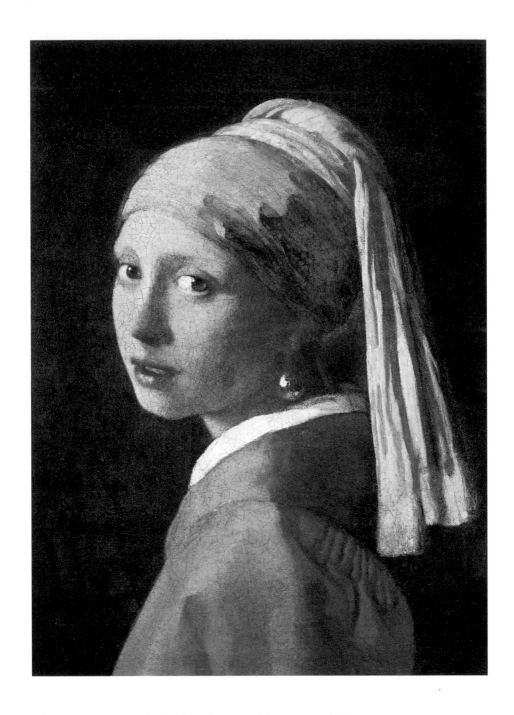

Johannes Vermeer, The Girl with a Pearl Earring, *c. 1665.*
The Hague, Mauritshuis.

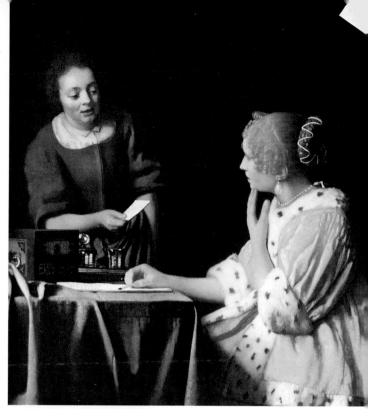

Johannes Vermeer,
Mistress and Maid,
c. 1667.
New York, The Frick Collection.

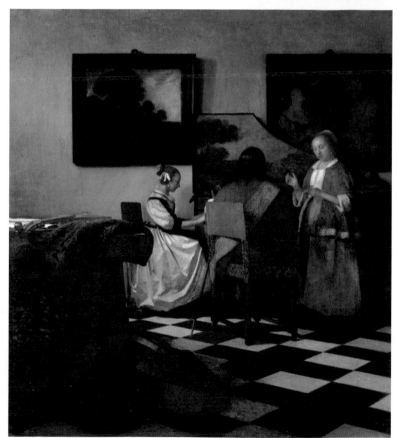

Johannes Vermeer, The
Concert, *c. 1665-1666.*
Boston, Isabella Stewart
Gardner Museum
(whereabouts at present
unknown).

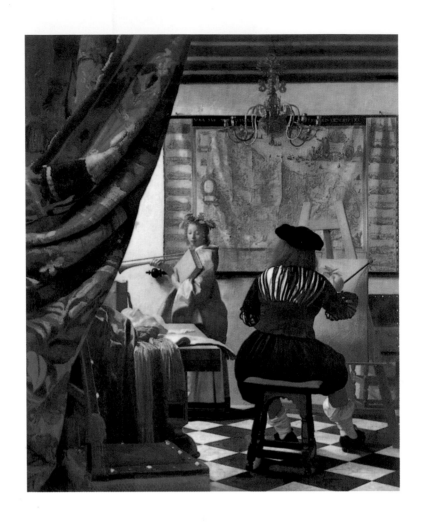

Johannes Vermeer, The Allegory of Painting, *c. 1666-1667.*
Vienna, Kunsthistorisches Museum.

The best works in this new style were painted about 1670 such as *The Lacemaker*, in which the artist concentrates on portraying human diligence to the exclusion of everything else. During the last years of his life Vermeer's paintings again portray music, as in *A Lady Standing at the Virginals* and *A Lady Seated at the Virginals*. This time he painted only women with their instruments, whereby the woman herself is the central figure, no longer a person in a room, as she was ten years earlier.

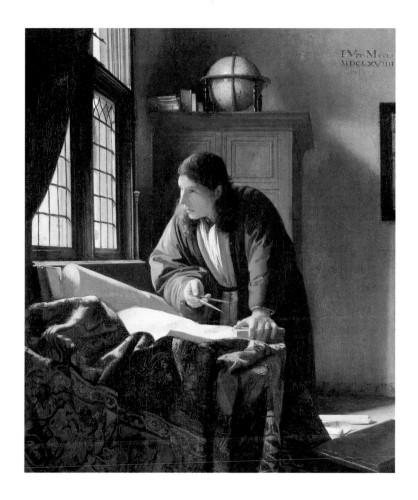

Johannes Vermeer, The Geographer, *1669.*
Frankfurt am Main, Städelsches Kunstinstitut.

The significance of Vermeer's work is to be found in the systematic development of themes and techniques which were introduced by other artists. Vermeer was certainly no great innovator, but he could raise the findings of others to a far higher plane. This gave his work its strength. Vermeer worked very slowly. He could not accomplish more than two or three paintings a year because of his extremely painstaking way of painting.

Thirty-one works have been preserved which can be firmly attributed to Vermeer and there are four or five about which there is some doubt. Taking into account that some paintings have been lost, Vermeer's complete works are thought to number between forty and fifty. This is a very small number when compared with the productivity of Rembrandt or Frans Hals. The following incident shows how slowly he worked: the French diplomat Balthazar de Monconys came to Delft in 1663, when he also visited Vermeer. Not one of his paintings was to be seen in his studio. To see one of the works he had to go to a Delft

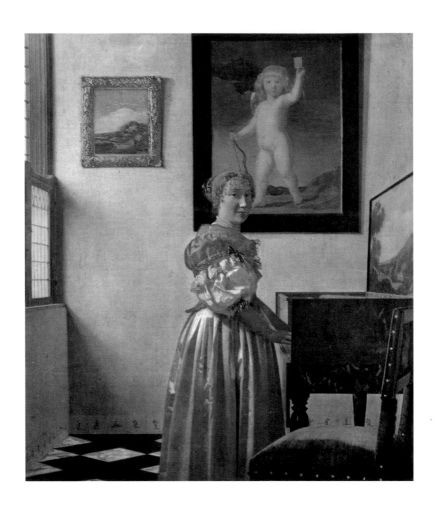

Johannes Vermeer, A Lady Standing
at the Virginals, *c. 1672-1673.*
London, The National Gallery.

baker's shop (probably Hendrick van
Buyten, who possessed four paintings by
Vermeer).
Vermeer worked mainly for local clients.
The wealthy Pieter van Ruijven of Delft
(1624-1674) had the largest collection; he
bought about half of Vermeer's oeuvre

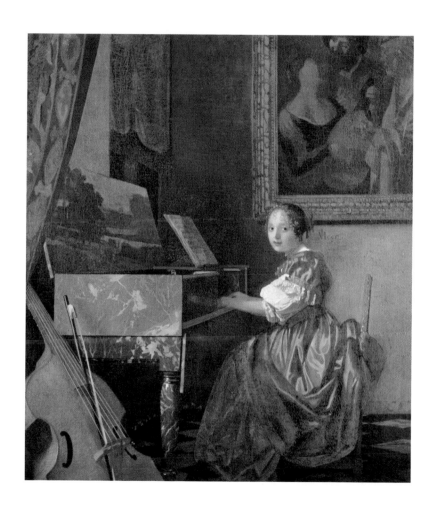

Johannes Vermeer, A Lady Seated
at the Virginals, *c. 1675.*
London, The National Gallery.

(i.e. fifteen works) between 1657 and 1675).
As long as his paintings stayed in the houses
of Delft, he remained quite unknown. Even
so his work was held in high esteem. When
his paintings began to circulate outside Delft
at the end of the seventeenth century, they
fetched high prices.

2 Vermeer's family

Nassau house

Vermeer's father, Reynier Jansz., was born
in 1591 in Nassau House in the
Broerhuisstraat near the Beestenmarkt. The
family was born and bred in Delft. His
father, Jan Reyersz. was a tailor, married to
Neeltje Goris. Reynier Jansz. was the eldest
of their three children. A daughter, Maertge
and a son, Antonij were born in due course.
Reynier was six years old when his father
died. Neeltge Goris was not a widow for
long. Five months after her husband's
funeral she married her neighbour Claes
Corstiaensz. who owned the house with
The Three Hammers. Neeltge was about
thirty at the time, Claes was forty-nine.

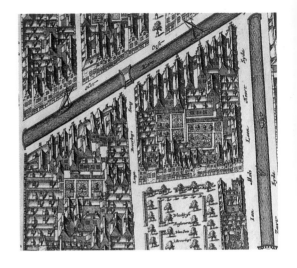

The Beestenmarkt, a detail of the Figurative
Map, *1675-1678.*
Delft record office.
*Vermeer's relations on his father's side lived
on the Beestenmarkt. Many artisans were
established around this marketplace.*

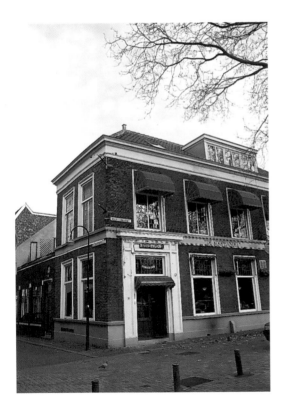

26 Beestenmarkt.
*Vermeer's father, Reynier Jansz. was born in this
house in 1591. It was called Nassau House then.*

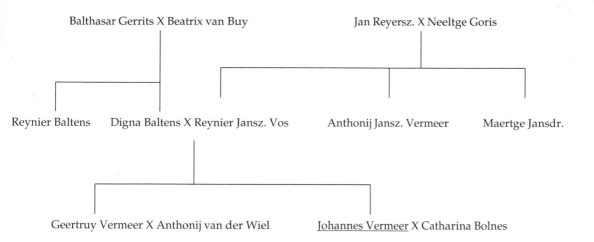

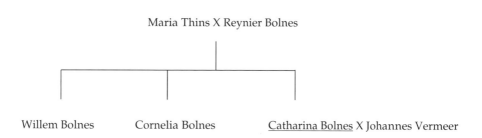

Vermeer's Family Tree

The House with The Three Hammers

Neeltge Goris moved into The Three
Hammers with her three children after her
marriage. Claes was a widower with a son,
Dirck. He was a tailor, like Neeltge's first
husband. Two years after the marriage they
had a daughter, Adriaentge, called after
Claes's first wife.

The house with The Three Hammers was
situated in the Broerhuisstraat on the side of
the Beestenmarkt **and** it had a sign with
three hammers on it. It was registered as an
inn in 1600 and Claes was the innkeeper. His
customers would have been craftsmen such
as smiths, barbers, coopers and potters
living in the vicinity of the Broerhuisstraat.
We know from documents that Claes was
also a minstrel who performed regularly at
weddings and other festive occasions.

In spite of its good location Claes's inn does
not seem to have drawn many customers as
he often had to borrow money. When he
died in 1617 he left his family with debts to
the tune of six hundred guilders, amounting
to two and a half times the annual wage of
an average workman. Neeltge Goris tried to
earn a living by selling old clothes and
bedding after the death of her second
husband.

She was married for the third time in 1620,
this time to Jan Michielsz. van der Beck,
a ship's carpenter from Delfshaven who was
quite well off. The marriage did not last long
as Jan Michielsz. fell ill and died the
following year. The inheritance left by her
husband was not sufficient to settle
Neeltge's debts. Her relations were called on
to stand surety for payment of her debts,
again and again.

Neeltge's financial situation had become so
serious by March 1624 that she was forced to
let The Three Hammers for three years, to
Willem Jansz. Meyns, a drummer in the
army of Prince Maurice. She moved to a
house in the Cruysstraat, to the south of the
Beestenmarkt. At the end of the lease she
returned to The Three Hammers, where she

died in September 1627 at the age of sixty.
Two months later, by order of the aldermen
the house was sold with all her goods and
chattels to settle her debts.

Vermeer's father had already left his
parental home The Three Hammers for good
and was living in another part of the town.
Reynier Jansz. began his career as a 'caffa'
worker. Caffa was a fine satin, woven from
silk and linen, usually with a flower
pattern. He was sent to Amsterdam in 1611
to learn this craft. There he met Digna
Baltens and they were engaged on 27th June
1615, when Reynier had just finished his
four-year apprenticeship. A month later
they were married in the Nieuwe Kerk at
Amsterdam. The young couple moved to
Delft and lived with Vermeer's grandmother
in The Three Hammers. Their first child,
Geertruy, was born here in 1620.

The cabinet maker's house

Vermeer's uncle on his mother's side,
Reynier Baltens, settled in Delft in 1618.
He was apprenticed to a cabinetmaker who
lived nextdoor to The Three Hammers Inn.
Here Reynier learned how to make the
wooden doors, windows and staircases
needed in a house. Reynier took a baby girl,
Tanneken, to be baptized in the Nieuwe
Kerk on 21 December 1618. The mother may
have died in childbirth as she is not
mentioned in the register of baptisms. The
baby's godparents were Reynier Jansz. and
Neeltge Goris, Vermeer's father and
grandmother. This incident shows the close
ties which existed between the families of
Vermeer's father and mother. This was
demonstrated again a year later when
Reynier Baltens was in serious trouble and
his sister Digna's in-laws supported him
once again.

In 1619 Vermeer's grandfather on mother's
side, Balthasar Gerrits from Antwerp,
started a dubious business after earlier
notorious speculation in East India
Company-shares. He rented a workshop on

the road to Scheveningen in The Hague, to forge coins with the help of an apprentice and his son Reynier Baltens. Financial backers of this enterprise were the businessman Gerrit de Bury and the ambassador of the Brandenburg Elector, Hendrick Sticke. No sooner were the first counterfeit coins struck than the authorities were informed. Balthasar fled back to Antwerp, while Reynier Baltens and the apprentice were arrested. Reynier was imprisoned in the Gevangenpoort (gatehouse) at The Hague. While he was held there, Neeltge Goris and four of her neighbours (including the cabinetmaker where Reynier had served his apprenticeship) presented themselves at the notary's office to declare that Reynier was a respectable young man who had always behaved correctly.

The affair of the counterfeit coins ended fatally for the two partners in crime. De Bury was arrested at Amsterdam while planning to continue the business elsewhere. He confessed to everything under torture on the rack. This led to the arrest of Hendrick Sticke, in spite of his being under the protection of the Brandenburg Elector. Balthasar and his son Reynier were acquitted in exchange for testimonies against their former patrons. Gerrit de Bury and Hendrick Sticke paid for their illegal practices with their lives: they were both beheaded on August 8th 1620.

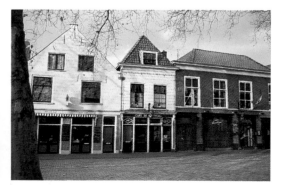

14-14a Beestenmarkt.
When Vermeer's father was six years old, he moved with his mother to his stepfather's inn on the north side of the Beestenmarkt. This was known as the Three Hammers Inn. His brother-in-law Reynier Baltens was apprenticed to a cabinetmaker in the house either to the left or the right of the inn.

3 The Artists's Youth

The Flying Fox Inn

Vermeer's parents, Reynier Jansz. and Digna Baltens probably moved house in the late 1620s. They may have lived somewhere else after The Three Hammers Inn was let in 1624, but it is certain that the couple lived on the Voldersgracht in 1631. They rented an inn there complete with a sign showing a flying fox. Reynier combined his duties as innkeeper with his old profession of 'caffa weaver', as shown in various notarial documents in which he is described as innkeeper and caffa worker. On 13th October 1631 Reynier Jansz. enrolled with the guild of St. Luke as an art dealer, which gave him the right to buy and sell paintings. Records show that Reynier was in contact with many artists in Delft such as Balthasar van der Ast and Jan Baptista van Fornenburgh who painted floral arrangements, the still-life artist Pieter Steenwijck and the landscape artist Pieter Groenewegen. Having neglected to pay a peat seller for a load of peat, Reynier Jansz. became involved with the man's son-in-law after his death; this was the noted portrait and interior artist Antonie Palamedes.

In 1632, a year after enrolling with the guild of St. Luke, Reynier's son Johannes Vermeer was born. (A daughter was born in 1620). Vermeer was most probably born in The Flying Fox Inn, but the exact date is unknown. Reynier was then forty-one years old and Digna was thirty-seven. The couple had already been married for seventeen years.

We know nothing about Vermeer's youth. There is no trace of the artist until his engagement in 1653. But we may assume that Johannes played outside on the Voldersgracht and nearby Markt as a small boy.

The Flying Fox Inn was in a better neighbourhood than The Three Hammers. There were five fireplaces on the premises which indicates that it was quite big. It was situated on the north side of the Voldersgracht, now number 25. The inn was the third house on the east side of the Oudemannenhuis (old mens'home), not the second, as Montias states in his book on Vermeer. We can verify this from the taxation register of 1632 and the book of fireplaces of 1638.

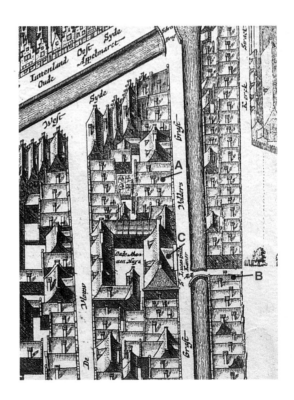

The Voldersgracht and surroundings, a detail from the Figurative Map, *1675-1678.*
Delft record office.
On the Voldersgracht are a) the Flying Fox Inn, where Vermeer lived the first years of his life; b) the Mechelen Inn, where he grew up; c) the Guild of St. Luke, of which he was a member.

did not suit him and he also stressed that he wished to continue the lease until the date of expiry. His wish was respected; when Hopprus sold the house on 15th May 1640, it was stipulated in the deed of purchase that Reynier Jansz. was entitled to occupy the premises until 1st May 1641. The annual rent of a hundred and thirty-eight guilders was duly deducted from the purchase price.

Coenraad Decker, The Nieuwe Kerk, c. 1680. Delft record office.
Vermeer was baptized in the Nieuwe Kerk at Delft on 31st October 1632. His parents were later buried in this church.

25 Voldersgracht
This house was an inn called The Flying Fox during the seventeenth century. Johannes Vermeer was born here in October 1632.

Reynier Jansz. signed a tenancy agreement for the inn with its owner, Pieter Corstiaensz Hopprus, a prosperous shoemaker and tanner. This was probably to renew an earlier contract as Reynier Jansz. was already living on the Voldersgracht in 1631, and registered as the innkeeper. The new lease expired on 1st May 1641. A year before this Reynier was approached by a notary who asked him if he would be interested in buying the premises for two thousand, one hundred guilders. Reynier replied that this

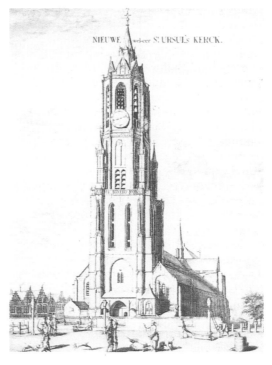

The Nieuwe Kerk (the new church)

Johannes Vermeer was baptized in the Nieuwe Kerk on 31st October 1632. Witnesses to the ceremony were Pieter Brammer, Jan Heijndrickxc. and Maertge Jansdr. Pieter Brammer is unknown, Jan Heijndrickxz. was probably a picture-framer and business associate of Vermeer's father and Maertge Jansdr. was Vermeer's aunt. Only the artists's Christian name, 'Joannes' was entered in the baptismal register of the Nieuwe Kerk. The origin of the name 'Vermeer' is not known. The first time it appears in records is on 6th April 1625 when Vermeer's paternal uncle took his daughter Neeltje to be baptized in the Nieuwe Kerk, giving his own name as Antonij Jansz. Vermeer. Vermeer's father did not use the name until later in life. He first took the name of Van der Minne, the family name of his stepfather, Claes Costiaensz. Later on, when he rented The Flying Fox Inn on the Voldersgracht, he called himself Reynier Vos, perhaps as a pun on the fable of Reynard the Fox.
From about 1640 onwards he was known as Reynier Vermeer.
Vermeer's elder sister Geertruy was also baptized in the Nieuwe Kerk, on 15th March 1620. Maertge Jansdr. had been a witness then just as she was now for her brother. The Nieuwe Kerk was the scene of baptizings in the Vermeer family, but they also buried their dead there. Vermeer's paternal grandfather Jan Reyersz. was buried there on 2nd May 1597, his father Reinier Jansz. on 12th October 1652 and his mother Digna Baltens on 13th February 1670.
The Nieuwe Kerk was built in the course of the fourteenth and fifteenth centuries on the east side of the Markt. The Virgin Mary is said to have appeared on the site in 1351, appealing for a church to be built there. A small church made of wood was first erected there, but the construction of a stone choir and transept was begun in 1383. The foundations of the tower were laid twelve years later and this was completed a hundred years later. The church was first dedicated to Mary and from 1400 to both Saint Ursula and Mary. When Delft took the side of William of Orange in 1572, the building was ordained for protestant worship. The church has suffered severely over the ages. The fire in 1536 destroyed a large part of the building and the iconoclasm of 1566, the powder explosion in 1654 and a stroke of lightning in 1872 have all left scars.
The members of the House of Orange-Nassau have been interred in the Nieuwe Kerk since 1584. At the beginning of the seventeenth century the noted sculptor and architect Hendrick de Keyser built a marble tomb in the apse, in honour of William of Orange. The tomb is in the form of a canopy resting on pillars. A marble effigy of the Prince of Orange on his deathbed forms the centrepiece and there is a bronze statue of him holding a martial staff in the forefront. The statue shows him in his capacitiy of military commander. A feminine figure on the other side represents Fame sounding the praises of the deceased. Beneath the tomb are the vaults where members of the House of Orange are laid to rest.
It seems that Vermeer and his family were faithful supporters of the House of Orange. An inventory of the possessions of Vermeer's father made in 1623, included four portraits of the stadholder's family: one of the Prince and the Princess, (perhaps this portrayed William of Orange and his fourth wife Louise de Coligny), a portrait of Prince Maurice and another of his younger brother Frederick Henry who was to succeed

The Nieuwe Kerk.
The tower of the Nieuwe Kerk can be seen in the distance on Vermeer's painting View of Delft. *The spire in the painting was struck by lightning in the nineteenth century. The present spire dates from 1875.*

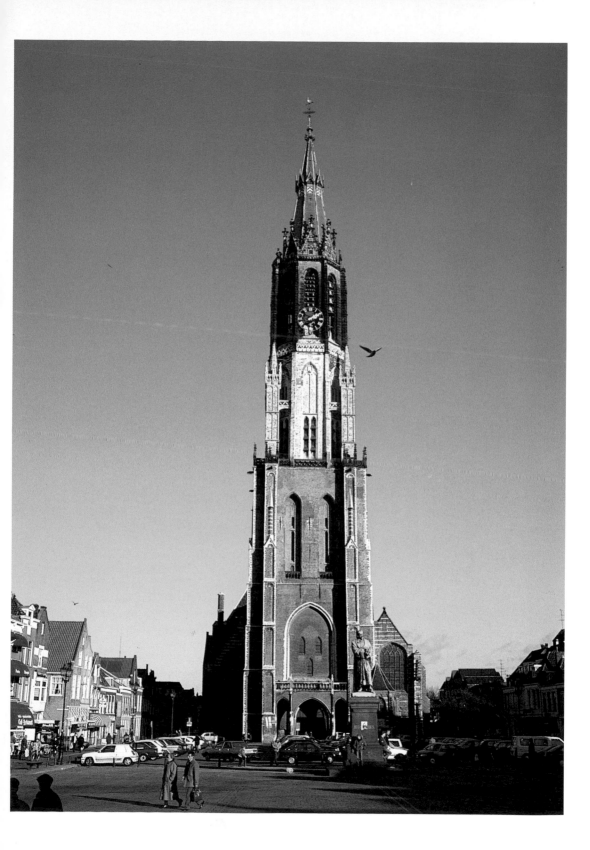

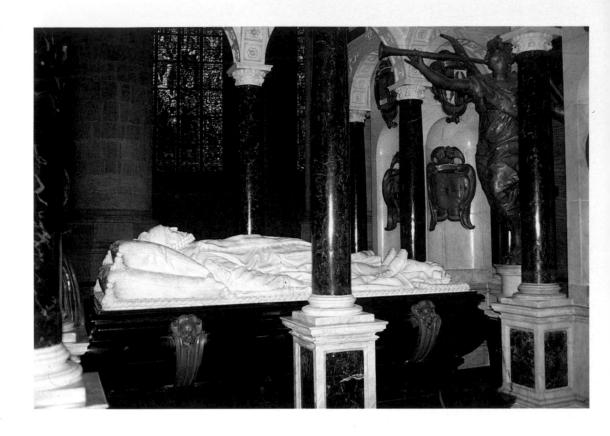

The tomb of William of Orange.
The tomb of William of Orange was built in the Nieuwe kerk between 1614 and 1623, in honour of this Prince who founded the State of the Netherlands.

Maurice as stadholder in 1625. The fact that the sun's rays fall exactly on the tower of the Nieuwe Kerk in his most famous painting, *View of Delft*, is often attributed to Vermeer's loyalty to the stadholder's family. The Republic was in its first stadholderless period (1650-1672) at the time when he painted it. The future stadholder William III was still a minor and the anti-stadholder regents seized their opportunity; led by Grand Pensionary Johan de Witt they ruled the Republic to the dissatisfaction of the Orangist part of the population. The Nieuwe Kerk with its tomb of William of Orange stood as a symbol of the power of the Orange dynasty during the seventeenth century. The tomb was the subject of countless paintings and people had their portraits painted in front of it.

Mechelen House

Vermeer's parents moved house when he was nine years old. In April 1641 Reynier Jansz. bought a large house, the Mechelen Inn on the Markt, at the corner with the Oude Manhuissteeg. The inn had large windows facing onto the Markt and no less than six fireplaces which made Mechelen House one of the most imposing buildings on the Markt. Reynier had to take out two mortgages to finance the purchase as his down-payment amounted to only two hundred guilders. The mortgages became a heavy burden on the family's finances. The Mechelen Inn was the bustling heart of the town. Its location, with the town hall on

one side and the Nieuwe Kerk on the other side was very favorable and an ideal meeting place for discussions and exchanging bits of news. The archives show that many Delft artists also used to meet here. Reynier Jansz. knew Evert van Aelst, the uncle and master of the painter Willem van Aelst; Emanuel de Witte had also been apprenticed to him. Egbert van der Poel, who painted the devastation caused by the powder explosion in Delft many times, and Leonaert Bramer who may have been Vermeer's master, were both in touch with Reynier. His membership of the guild of St. Luke and his activities as an art dealer will certainly have had a great influence on Vermeer's artistic development which really began in Mechelen House.

It has already been mentioned in the preface that we have no information concerning Vermeer's youth or his apprenticeship. The Delft archives have been searched for clues to his training for over a hundred years, without success to this day. Many of the artists known to Vermeer could have been his master, for instance the portrait and genre painter Gerard Ter Borch, Evert van Aelst and Carel Fabritius, who was ten years

Leonard Schenk, after Abraham Rademaker,
View of the Market, *c. 1720.*
Delft record office.
The Markt is and was the most important part of Delft. The town hall and the Nieuwe kerk stand opposite each other. The designer of this print has taken some liberties. The tower of the Oude Kerk, to the left in the background, is not visible from this point.

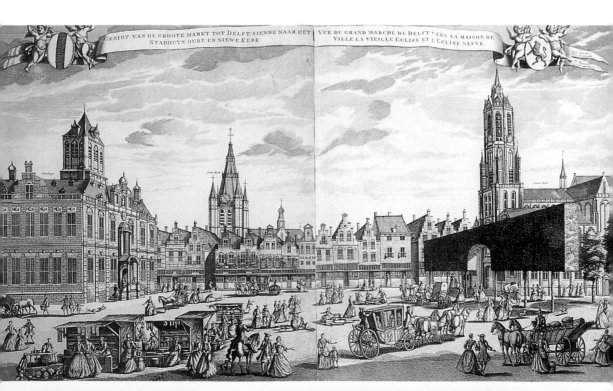

Leonard Schenk, after Abraham Rademaker,
The Mechelen Inn, a detail of View of the
Market, *c. 1720.*
Delft record office.
At the corner of the Oude Manhuissteeg on
the north side of the Markt stood The Mechelen
Inn, to which Vermeer and his parents moved
in 1641.

older than Vermeer. Others could be
considered including Willem van Vliet, the
famous Delft portrait painter Jacob II
Willemsz. Delff, Leonaert Bramer, Hans
Jordaens, Balthasar van der Ast, Willem van
Aelst, Antonie Palamedes, Pieter de Hooch
and Frans van Mieris. It may well be that
Vermeer left Delft to study elsewhere, for
instance in Amsterdam or Utrecht. The artist
Abraham Bloemaert, who was related to
Vermeer's wife, worked in Utrecht. Vermeer
may have been apprenticed to him when he
met his future wife Catharina Bolnes. But we
cannot be sure of anything concerning
Vermeer's training until the archives yield
fresh information.

When Vermeer's father died in 1652, Digna
Baltens carried on her husband's inn. The
inheritance cannot have amounted to much.
Soon after his death, widow Vermeer
bought a length of material for seventeen
and a half guilders on account, presumably
to make mourning clothes. Five years
passed before she was able to pay the
draper. It is not known where Vermeer
settled after his marriage in 1653, but it is
generally assumed that the couple moved in
with his mother at the inn on the Markt,
although there is no evidence to support
this. We know Vermeer's address for certain
from 1660, when he was living with his
mother-in-law Maria Thins, in her house on
the Oude Langendijk.

Digna tried to sell Mechelen House at
auction in 1669. She had set a reserve price
of three thousand seven hundred guilders
which was not reached, so the house was
withdrawn from auction. As a result of this
failure she let the inn to Leendert van
Ackerdyk, who paid a hundred and ninety
guilders per annum for it. The inn was let

The memorial tablet of Mechelen House.
A memorial tablet was attached to the house
standing next to the site of Mechelen House, in
1955. The inscription on the stone reads that
Vermeer was born here, which is incorrect.

vacant, only the racks for jugs and tankards remained. Digna Baltens moved in with her daughter Geertruy who lived in the Vlamingstraat. She died there on the 10th or 11th of February 1670. The inn passed to Vermeer after her death. He let Mechelen House again at the beginning of 1673, to his namesake the schoolteacher Johannes van der Meer, who paid a hundred and sixty guilders per annum.

Mechelen House was pulled down in 1885 to widen the Oude Mannensteeg, which connects the Markt to the Voldersgracht. In 1955 a memorial tablet was placed in the wall of the adjoining house at number 52 the Markt, to mark the spot where Mechelen House once stood. The Delft sculptor Joh. Bijsterveld made the memorial tablet, which bears the following inscription: "Here stood Mechelen House where the artist Jan Vermeer was born in 1632". This contains two mistakes. Vermeer was certainly not born in Mechelen House as his parents

moved there when he was already nine years old. The name Jan is not entirely correct either. Vermeer never used the name himself. He always signed deeds with Joannes, Joannis or Johannis. Criticism was heard on all sides in 1955, but the foundation "Delft binnen de veste" (Delft within the ramparts) which devised the inscription, decided that the Christian name Jan had become more familiar.

The site where Mechelen House stood.
Mechelen House had to make way for the
Oude Manhuissteeg to be widened.
The Jan Vermeer school can be seen at
the end of this alley.

The town hall

The first record concerning Johannes Vermeer after his entry in the baptismal registry of the Nieuwe Kerk, is a testimony dated 5th April 1653, drawn up by request of the artist and his future wife, Catharina Bolnes. The document states that Catharina's mother, Maria Thins, did not approve of her daughter's suitor, but that she would not stand in the way of their marriage. One of the witnesses to this statement was Leonaert Bramer. The young couple went to the town hall to proclaim the banns on the same day that Bramer made

Anonymous, The fire of Delft town hall in 1618, c. 1620.
Delft, Stedelijk Museum Het Prinsenhof.
The town hall was largely destroyed by a fierce fire in 1618. The people in the foreground have formed a chain to pass buckets of water along. The houses on the right are protected by the sails of ships from Delfshaven.

the statement. Entries of this kind were made in three registers in the seventeenth century: The civil register at the town hall, and the registers of banns of the Nieuwe Kerk and the Oude Kerk. Neither of the church registers for the period from 1650-1656 has been preserved so that we are dependent on the civil register. A note in the margin reads: "Certificate issued at Schipluij (Schipluiden) on 20th April 1653". This indicates that the marriage took place at Schipluiden, a village south of Delft where many catholics lived. The Jesuits held Roman catholic services there openly. Vermeer's in-laws were catholics and Maria Thins had close connections with the Jesuits. This may have been the reason why the young couple was married at Schipluiden. Vermeer, who was brought up a protestant, must have converted to catholicism to receive the catholic sacraments of holy matrimony. This he must have done between 5th April, when Bramer testified on behalf of Vermeer, and 20th April 1653, their wedding day. It is possible that Maria's

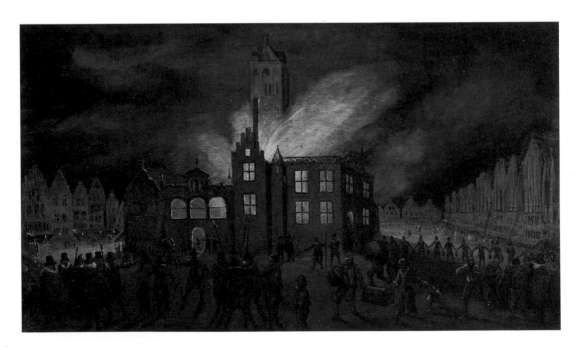

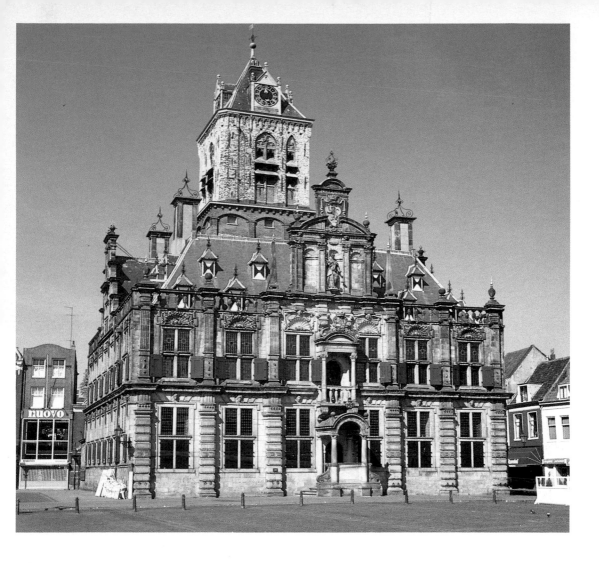

The town hall of Delft.
The facade was restored to its original
seventeenth-century state during renovation
in the 'sixties, when all later additions were
removed.

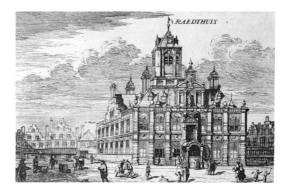

Coenraad Decker, The Town Hall, c. 1680.
Delft record office.
The town hall was rebuilt by the well-known
architect Hendrick de Keyser after the fire.
The harmonious construction of the facade makes
it one of the loveliest town halls in the Northern
Netherlands.

doubts about her daughter's marriage sprang from the fact that Vermeer was a protestant. It could also be that this wealthy lady thought that an impecunious and unknown artist was a thoroughly undesirable match for her daughter.

The town hall of Delft, where Vermeer proclaimed the banns, was rebuilt after a fire by Hendrick de Keyser in 1618. All that is left of the old medieval building is the high, square tower, known as The Stone. Part of the tower was used as a prison. Some of the prison accommodation is still in the original state. Hendrick de Keyser designed the facade of the new town hall in late renaissance style. A porch was built over the entrance, enabling condemned prisoners detained in The Stone to be led straight out to the scaffold which was erected in front of the town hall whenever there was an execution. High up in the facade is the coat of arms of Holland and a statue of Justice holding her symbols, the sword and the balance. The coat of arms of Prince Maurice can be seen underneath the statue of Justice. The building was considered the most beautiful town hall in the Northern Netherlands, until Jacob van Campen built the new town hall at Amsterdam, which is now the Royal Palace.

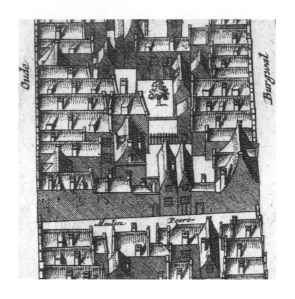

The surroundings of the Oude Langendijk, a detail from the Figurative Map, *1675-1678. Delft record office.*
The house of Vermeer's mother-in-law which was the home of the artist and his family, stood on the Oude Langendijk, at the eastern corner of the Molenpoort. The map shows clearly that it was a fair-sized, deep house. There was a canal in front of it which has since been filled in.

The Maria van Jessekerk.
The Maria van Jessekerk was built on the site of Vermeer's house in the nineteenth century. The clandestine church of the Jesuits nextdoor to it was pulled down at the same time.

44

4 Vermeer of Delft

Vermeer's house

Vermeer lived for a large part of his life with his family in the house of his mother-in-law, Maria Thins, on the Oude Langendijk at the corner of the Molenpoort, now the Jozefstraat. It is not known when Vermeer moved in there. The register of burials of the Oude Kerk shows that the artist was living at the Oude Langendijk in December 1660. It is not likely that he would have done so when he was first married. The fact that Vermeer was not able to pay his enrolment fee for the guild of St. Luke in December 1953 points to this. He did not pay it until three years later. If he had been living with his well-to-do mother-in-law she would surely have advanced him the six guilders, if only to help her daughter. Also, the fact that his mother-in-law was not at all happy with her daughter's husband at first, makes it unlikely that Vermeer and his wife lived on the Oude Langendijk during the first years of their marriage.

The house was bought in 1641 by Jan geensz. Thins from Gouda, a cousin of Maria's. It is not quite clear why he bought the house. The Thins were devout catholics. Mass was even celebrated secretly at Maria's parental home in Gouda. Jan probably bought the house on behalf of the Delft Jesuits, who owned some of the adjoining buildings and who let the house. It is not likely that he lived there himself.

Maria Thins was married to Reynier Bolnes, a wealthy brickmaker from Gouda. The marriage was not a happy one. There were constant quarrels between them. Their marital problems were described in detail in the judicial archives of Gouda. The marriage was dissolved officially in 1641 and Maria was granted custody of her two daughters, Cornelia and Catharina, later to be Vermeer's wife. A son, Willem, was left in the care of his father. Maria left for Delft with her daughters soon after this, where,

according to a document dated 1647, she lived in a house in the Vlamingstraat with her brother Jan. A record from 1651 states that she lived on the Brabantse Turfmarkt together with her sister, again in her brother Jan's house so they must have moved. In 1653 Maria Thins was living on the Oude Langendijk in the house bought by her cousin in 1641. Thanks to an inventory made two months after his death, we have ample information on the rooms and the layout of Vermeer's house. There was a vestibule on the ground floor with a painting by Fabritius on the wall. Behind this was the big hall containing two more portraits by Fabritius. There was a small cabinet next to the big hall. Also on the ground floor were two kitchens, a scullery, a wash house, a corridor, a cellar room, a courtyard and a small room between the ground floor and the first floor. There were a front room and a back room on the upper floor. The front room was appointed to be the studio facing north. Painters were advised in manuals to choose a studio facing north, to keep the sunlight out of their work area. It was long considered impossible to reproduce naked sunlight shining into a room. The Delft painters demonstrated that the opposite is true. In Vermeer's studio the notary's clerk listed the inventory as two easels, three palettes, six brushes, three bare canvases, one desk and three bundles of assorted prints, which were probably used as models. Most of the rooms described in the inventory were on the ground floor, so it is most likely that Vermeer lived in this part of the house with his family, and that he worked upstairs, with Maria Thins occupying the rest of the upper floor. Vermeer's mother-in-law was always a great help to the family, often supporting them financially. Vermeer and his wife had fifteen children altogether (four of them died in infancy) and this large family was a heavy financial burden.

It is often noted that the serenity radiating from Vermeer's paintings contrasts sharply with his busy domestic life and the incidents between his in-laws, Vermeer's brother-in-law, Willem Bolnes on the one hand and his wife and mother-in-law on the other hand. William had chosen the side of his father after his parents divorce, and he stayed in Gouda. He visited Delft in 1663 to acknowledge a debt to his mother which seems to have started a quarrel, because eyewitnesses reported that William had more than once caused a dreadful commotion in front of Maria Thin's house, and that he had continually threatened to beat his pregnant sister Catharina with a stick. About a year after William Bolnes' outbursts, Maria Thins obtained permission from the town council to have her son confined in a private 'house of correction' in the Vlamingstraat. It is probable that he stayed there until his death, a few months after Vermeer died. The house on the Oude Langendijk no longer exists. A neoclassicist church was built in its place in 1837. This was replaced by the present Maria van Jesse Kerk in Gothic-Revival style in 1877.

Johannes Vermeer, Allegory of the Faith,
c. 1671-1674.
New York, The Metropolitan Museum of Art.
The obvious glorification of the catholic faith
in this painting suggests that it was made for
a catholic patron. It is possible that the work
was commissioned by the Delft Jesuits who
lived nextdoor to Vermeer.

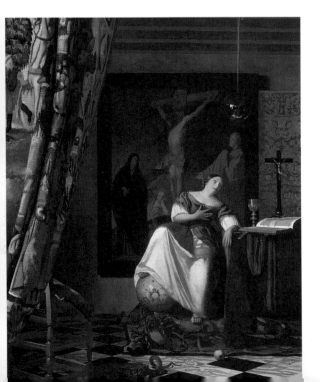

Abraham Rademaker, The church of the
Jesuits, c. 1700.
Delft record office.
The church of the Delft Jesuits was nextdoor
to Vermeer's house. Two people are just going
into the house which is the original church.
The building to the right of it is an extension
added in about 1678. The house on the extreme
right may be the one belonging to Vermeer's
mother-in-law, where the artist lived.

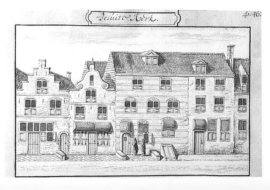

The church of the Jesuits

There used to be a Jesuit church next to the house where Vermeer lived with his family in the seventeenth century. In those days catholics belonged to a tolerated minority, living mainly in Paepenhoeck (Pope's corner), around the Oude Langendijk.
A drawing made by Abraham Rademaker at the beginning of the eighteenth century shows the 'conventicle' of the Jesuits. The house with two figures entering it is the church as it was in the time of Vermeer. The extension on the right was added in 1678. Part of Vermeer's house may be visible on the far right, while the building on the left was the house of the Jesuits and the school which Vermeer's children may have attended. The church was taken over by the Franciscans in 1709.

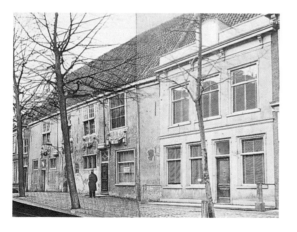

St. Luke's Guildhall just before it was pulled down, c. 1875.
Delft record office.
St. Luke's Guildhall fell into disrepair during the nineteenth century and it was pulled down in 1876. This photograph shows the building shortly before it was demolished. The pediment had already gone but the four garlands were still in place.

That Vermeer and his family were fervent catholics is evident from the fact that one of his children was named Ignatius after Ignatius Loyola, the founder of the Order of Jesuits.
A remarkable picture painted by Vermeer towards the end of his life also denotes his religious convictions. The work, *Allegory of the Faith* finishes with calvinism by way of symbolism, while simultaneously glorifying catholicism. A woman sits at the centre, her eyes raised pathetically to heaven, her right foot on a globe. There is a snake in the foreground (perhaps a symbol of protestant heresy) with blood pouring from its mouth, in the throes of being crushed by a stone - a refererence to the rock on which Peter built the church of Rome. The explicit commentary on the religious situation in the Netherlands suggests that the work was probably commissioned. The Jesuits have often been mentioned in connection with this painting.

St. Luke's Guildhall

Just six months after his marriage, on 29th December 1653 when he was twenty-one years old, Vermeer presented himself for membership of the guild of St. Luke as a master artist. Delft artists, like craftsmen and tradespeople belonged to their own guild. Their patron was the evangelist Luke who, according to tradition, once painted Mary with the Christ-child. The enrolment fee was six guilders, of which Vermeer paid one and a half guilders. His financial position was evidently so poor that he was not able to pay the whole fee at once. He did not pay the remainder until two and a half years later, on 24th July 1656.
The guild of St. Luke must have been founded in the Middle Ages but it was first mentioned in documents in 1545. It was the most important and biggest guild in Delft. It was composed of artists, house painters and decoraters, glass engravers, stained-glass workers, glaziers, potters,

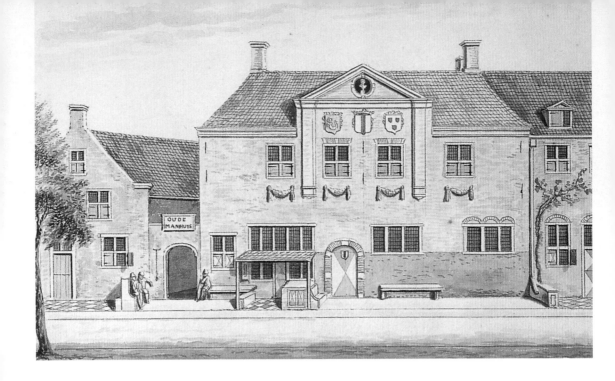

Abraham Rademaker, St. Luke's Guildhall,
c. 1700.
Delft record office.
The chapel of the Old Men's Home was rebuilt in
1661 to serve as accommodation for the guild of
St. Luke. Four garlands showing the tools of the
four most important crafts decorated the facade
and a bust of Apelles was placed in the pediment
above the entrance.

G. Lamberts, View of St. Luke's Guildhall
from the Oude Manhuissteeg, 1820.
Delft record office.
The way to St.Luke's Guildhall from the Markt
went via the Oude Manhuissteeg. This early
nineteenth-century drawing shows the facade of
the Guildhall seen from the Oude Manhuissteeg.
The house on the left is Mechelen House, the inn
belonging to Vermeer's father.

embroiderers, carpet weavers, sculptors, engravers, booksellers, printers and art dealers. The guild promoted the interests of its members while it also supervised the quality of their work. Only those artists who belonged to the guild had the right to sell their works in Delft.

Delft painters, in contrast with glaziers and potters, were not obliged to submit a masterpiece, but they had to complete their six years of apprenticeship before enrolling with the guild.

The Board of the guild of St. Luke comprised six members (two potters, two stained-glass artists and two painters) under the leadership of a dean who was a member of the council of forty, a municipal advisory body. The members of the Board were appointed for a two-year period. Every year on St. Luke's day (18th October) the members of the guild chose three new Board members (one from each vocation). Two candidates were nominated for every vacancy, from which the mayor and aldermen made their choice before the end of the year.

Vermeer was a Member of the Board twice during his life. He was chosen in 1662 at the age of thirty, one of the youngest Board members in the history of the guild. He held the position again from 1671 to 1673.

The guild flourished and this is apparent by the occupation of a new guildhall on the Voldersgracht. The guild was granted the use of the chapel of the former Old men's home in 1661, which had been in use as the clothmakers' and serge hall. The clothmakers' guild was then transferred to the Prinsenhof. The former chapel was renovated intensively. On the canal side the building was given a classicist facade with a pediment and mullioned windows. In it was a bust of Apelles, the legendary painter from Antiquity. Below it were the coats of arms of the town of Delft, the guild of St. Luke and the dean of the guild in 1661, Dirk Meerman. Striking features of the guildhall were four sculptured white-stone garlands, displaying

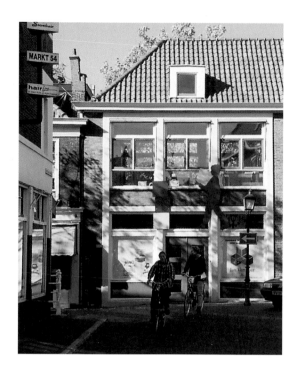

21 Voldersgracht.
The Jan Vermeer School was built on the site of St. Luke's Guildhall in the nineteenth century. It was replaced by a more modern building a century later.

the tools and products of the four main crafts represented by the guild: the glaziers, booksellers, potters and of course, the artists.

The members decorated the interior themselves. The two Board members representing the painters in 1661, Leonaert Bramer and Cornelis de Man painted a fresco on the ceiling and a large mantel painting respectively for the guild-hall. Adriaen van de Velde and Arent van Saenen, members for the glaziers, made all the windows, while the potters joined in donating ten chairs upholstered with Russian leather.

49

The guild of St. Luke was dissolved in 1833. The guildhall fell into disrepair and when it was pulled down in 1876, a school was built in its place. The four garlands were transferred to the Rijksmuseum at Amsterdam where they were built into the walls of the 'Fragmentengebouw'. The handsome pediment with the bust of Apelles and three coats of arms had already disappeared by that time. The Jan Vermeer school now stands in the place of the guildhall.

Leonaert Bramer, Design for mural decorations of the New 'Doelen', *c. 1660.*
Delft, Stedelijk Museum Het Prinsenhof.
Leonaert Bramer was commissioned to decorate the hall in the New Shooting Range c. 1660. This triptych is his draft design fo it. A parade of the guards is shown in the centre with the Captain at the head followed by his officers.

The 'Doelen' or shooting range of the Delft civic guard

Very little is known about Vermeer's activities apart from his painting. His name was discovered recently on a list of civic guards dated 1664. The most important duty of the civic guard was to defend the town. Guards were expected to assist in keeping public order in case of emergencies. All able-bodied men of some substance were obliged to take part in the exercises of the guard. The Delft civil guard was reorganized by order of William of Orange in 1580. The town was divided into four quarters, each with its own company, referred to by the colour of its banner. The Green, Orange, White and Blue companies were formed with a captain at the head of each, assisted by a lieutenant, an ensign and two or three sergeants. A company consisted of six squads of thirty-two guards. Vermeer was a guard in the Orange company. An inventory of 1676 shows that he was equipped with armour, a helmet and a pike. He went to Gouda on 8th May 1673 under the leadership of Captain Van Hurk to fight the French troops who had invaded the Netherlands.
The Delft civil guard met in the new 'Doelen' or shooting range on the Verwersdijk after 1655. The old Doelen building had been destroyed in the powder

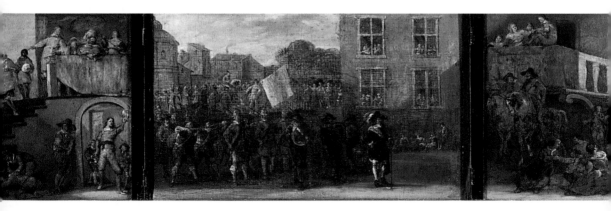

explosion of 1654, along with some of their group portraits. Only four of these could be restored. The town council put the site of the former convent of Mary Magdalene at the disposal of the Delft civil guard for their new accommodation. Leonaert Bremer was commissioned to paint mural decorations in the hall. Bramer was a sergeant in the same company as Vermeer. There is a triptych by Bramer in Stedelijk Museum the Prinsenhof, which was probably the draft design for these murals. The Doelen was demolished in 1830 to be replaced by a theatre which has also disappeared in the meantime.

Coenraad Decker, The New 'Doelen', c. 1680.
Delft record office.
After the powder explosion of 1654 the Delft civil guard acquired new accommodation on the Verwersdijk on the site of the former Convent of Mary Magdaline. The 'Anatomie', where surgeons used to meet, was nextdoor to the shooting range.

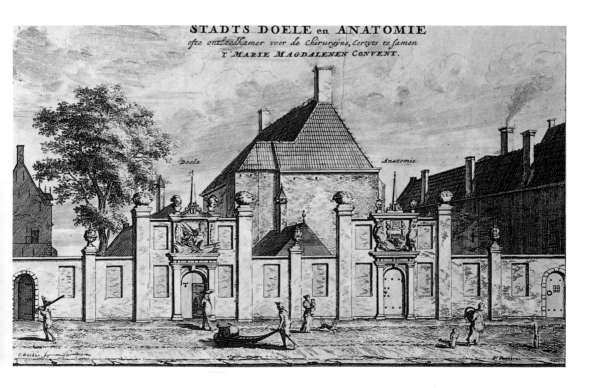

5 Vermeer's Delft colleagues

The house of Balthasar van der Ast

The records show that Vermeer's father was on good terms with Delft painters. One of these was Balthasar van der Ast (1593/94-1657), who was trained at Middelburg and Utrecht. He came to Delft in 1632 and painted still-life pictures with flowers, fruit and seashells. He was a regular visitor to the inn of Vermeer's father and it may well be that he got to know Vermeer as a boy. When Vermeer enrolled with the guild of St. Luke in 1653, Van der Ast was already sixty and one of the older generation of Delft painters. He was buried in the Oude Kerk in 1657.

Balthasar van der Ast's house was situated to the east of the Oude Delft, at the corner of the Oude Kerkstraat. The front of the house dates from the beginning of the twentieth century.

Isaak van Haastert, View of the Oude Delft. *Delft, Stedelijk Museum Het Prinsenhof. This late-eighteenth-century painting shows the house of Balthasar van der Ast on the corner, to the left of the Oude Kerk, as it looked in the seventeenth century.*

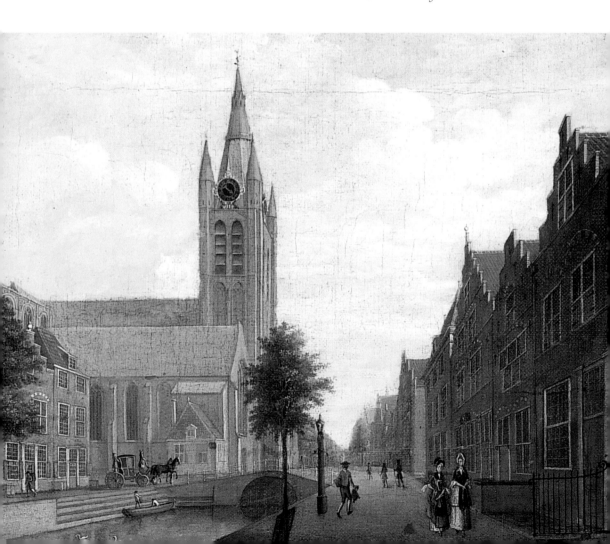

Leonaert Bramer and the Prinsenhof

Stedelijk Museum the Prinsenhof is housed in what used to be the St. Agatha convent in the fifteenth and sixteenth centuries. The building was confiscated by the States of Holland in 1572 and put at the disposal of William of Orange, who was assassinated there on 10th July 1584. Two bullet holes still mark the spot.

The building was used for various purposes in Vermeer's day. Important guests of the town council were lodged there. Samplers of the drapers' trade who had used the Old men's home until the guild of St. Luke moved into it, now occupied part of the premises.

The walls and ceiling of the Great Hall in the Prinsenhof were decorated by Leonaert Bramer between 1667 and 1669. This is the only surviving decorated ceiling painted by Bramer. The paintings were badly damaged

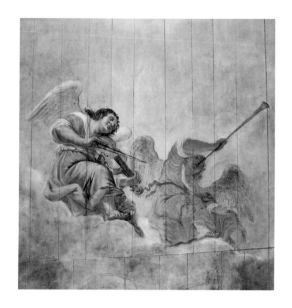

Leonaert Bramer, Angels making music, *a detail of the painting on the ceiling of the Great Hall of the Prinsenhof, c. 1667-1669. Delft, Stedelijk Museum Het Prinsenhof. Leonaert Bramer decorated the ceiling and the walls of the Great hall in the Prinsenhof by order of Delft town council. The mural painting has disappeared in the meantime, only the ceiling decoration was preserved.*

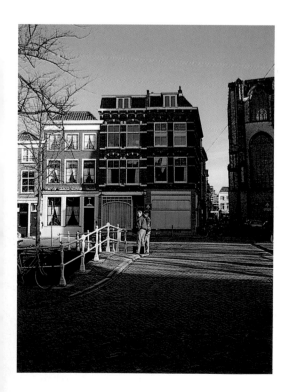

144-146 Oude Delft .
The facade of Balthasar van der Ast's house dates from the beginning of the twentieth century.

The Prinsenhof.
Today the Prinsenhof is a museum. It houses a large collection of objects and paintings concerning the history of Delft and the Eighty Years War.

Coenraad Decker, The Prinsenhof, c. 1680. Delft record office.
The Prinsenhof was the home of William of Orange in the sixteenth century. After his death the building was used for various purposes by the town council.

FRANSE KERCK eertijdts S.ᵗ AGAAT's CAPEL, welckers
westelijcste gedeelte geapproprieert is tot de LAKEN~HAL.

OUDE PRINSEN~HOF dienende nu voor een gedeelte
tot de SAY~HAL.

Apartement vande PRINCESSEN
van PORTUGAEL.

Decker Fecit

during the last century when the building was in use as a barracks. At that time the Great Hall was used for gymnastics and the apparatus hung from hooks in the ceiling. The spilled contents of chamber pots from the dormitory above did nothing to improve Bramer's painting.

It is often thought that Vermeer was apprenticed to Bramer because he testified on Vermeer's behalf in 1653, that Vermeer's mother-in-law would not stand in the way of her daughter's marriage, in spite of her objections. Another sign is that Vermeer began his career by painting biblical and mythological subjects, which were Bramer's speciality. On the other hand, the monumental style and sheer size of Vermeer's early works show hardly any affinity with the delicate style of Bramer's small paintings.

Jan Steen's brewery

On 22nd July 1654 Jan Steen (1625/26-1679) and his father rented the brewery 'In de Slange' for a six-year period. Situated on the east side of the Oude Delft, it was later called "The Roskam" (the currycomb). Jan Steen may have lived in Delft at that time, but there is no firm evidence for this. He never enrolled with the Delft guild of St. Luke and the only proof that he was ever in Delft is the painting *The Burgher of Delft and his Daughter* . The painting portrays a wealthy burgher with his daughter before their home on the Oude Delft, with the tower of the Oude Kerk and the town-hall in the background.

Before turning his attention to popular genre paintings, Jan Steen painted several religious and mythological subjects in his youth, including *Christ in the House of Martha and Mary*. This painting resembles Vermeer's earliest known work of the same name. The position of Christ with Mary at his feet is very similar in both paintings. Neither of the works is dated, but they were both painted about 1655 so that it is difficult

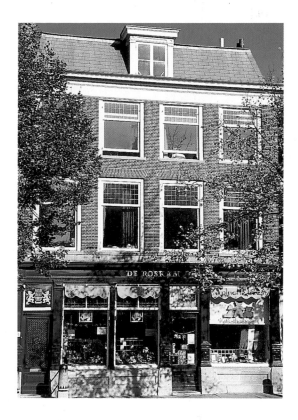

74 Oude Delft.
The premises in which Jan Steen had his brewery are still standing. The name was already changed to the 'Roskam' or currycomb, in the seventeenth century.

to say whether Jan Steen was influenced by Vermeer, or just the reverse. In any case both artists were well acquainted with each other's work in their youth.

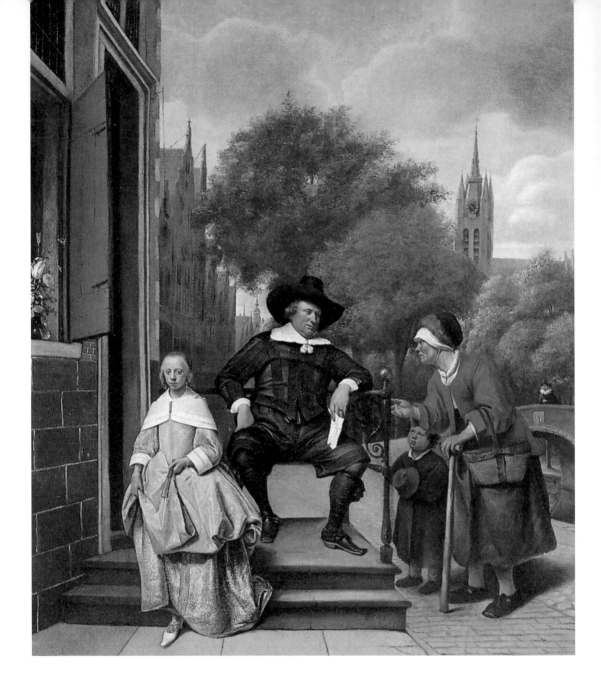

Jan Steen, The Burgher of Delft and his daughter, *1655.*
Penrhyn Castle, The National Trust.
The only proof that Jan Steen was also active as an artist in Delft, is this painting of
a Delft burgher before his house on the Oude Delft. It is said to portray one of the
four burgomasters in office in 1655.

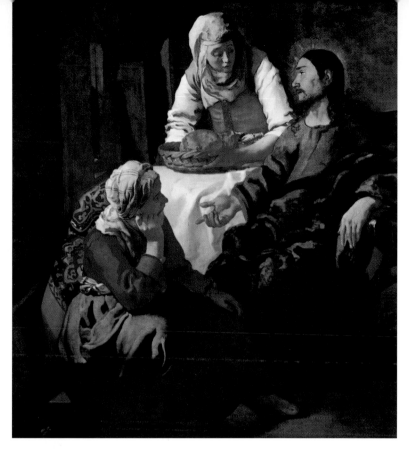

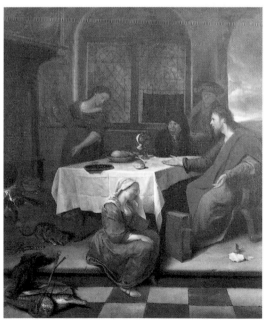

Johannes Vermeer, Christ in the house of
Martha and Maria, *c. 1655.*
Edinburgh, National Galleries of Scotland.
One of Vermeer's earliest works is this depiction
of Christ visiting Maria and Martha. Jan Steen
also painted this episode from the Bible.

Jan Steen, Christ in the house of Martha and
Maria, *c. 1654-1656.*
Nijmegen, private collection.
In the period that Vermeer painted his scene
from the Bible, Jan Steen painted the same
subject. The two works are very similar.

Adam Pick's house

Adam Pick (ca. 1622- before 1666) was one of the artists painting in Delft between 1642 and 1653. He lived on the Oude Langendijk where he was innkeeper of the inn "De Toelast". He sold his inn for seven thousand guilders in 1652 and left for Leiden. The only known painting by Pick is now in Stedelijk Museum The Prinsenhof. There is also a drawing of one of his paintings made by Leonaert Bramer. This drawing has special significance because it is possible that the painting depicted in Bramer's sketch belonged to Vermeer's father. The composition of one of Vermeer's early paintings, *Girl reading a letter at an open window* can be traced back to the painting by Pick. The table with its still-life arrangement defining the foreground and the curtain on the left are present in both pictures. Vermeer was obviously influenced by the work of Adam Pick at the beginning of his career.

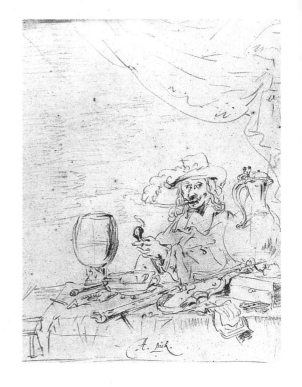

Leonaert Bramer after Adam Pick, Still-life with man smoking, c. 1652/1653.
Amsterdam, Rijksprentenkabinet.
About mid-seventeenth century Leonaert Bramer made a drawing of a painting by Adam Pick. This work may have belonged to Vermeer's father. The composition of the drawing is very similar to one of Vermeer's earliest interiors.

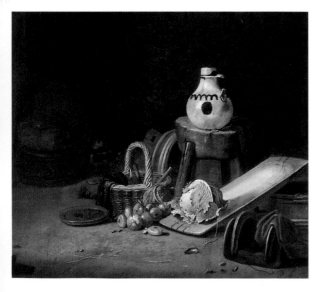

Adam Pick, Farmhouse interior with still-life.
Delft, Stedelijk Museum Het Prinsenhof.
Only one painting by Adam Pick has been preserved: a still-life with a farmer seated in the background.

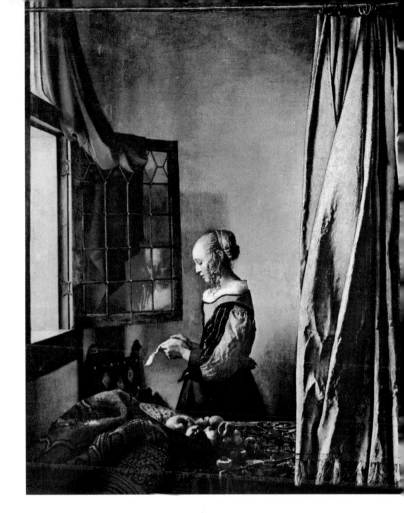

Johannes Vermeer, Girl Reading a letter at an open window. *c. 1657.*
Dresden, Staatliche Kunstsammlungen Gemäldegalerie, Alte Meister.
The composition of this painting, with a table in the foreground and a curtain on the left can be traced to a painting by Adam Pick.

13 Oude Langendijk.
Adam Pick lived on the Oude Langendijk, not far from the house where Vermeer was to live later. Like Vermeer's father, he had an inn, called the 'Toelast'. The present facade dates from the beginning of the twentieth century.

59

Fabritius' painting View in Delft

Vermeer's paintings of Delft are in keeping with the local tradition of the townscape. In the mid-seventeenth century several Delft artists specialized in portraying their town. While the townscapes from the first half of the seventeenth century show the town-profile from the outside, the later views of Delft show the town as seen from within its gates. *The Little Street* is a good example of this. *The View of Delft* is more complicated. The painting portrays Delft seen from the outside, but at the same time it has been painted from nearby. Not the whole town is shown, so that Vermeer concentrated on a small part of the southern town wall only. In this sense the *View of Delft* conforms to the innovations in Delft painting of the mid-seventeenth century.

Carel Fabritius, View in Delft, *1652.*
London, The National Gallery.
Fabritius' townscape is one of the first paintings to portray the town of Delft from within. The remarkable perspective was probably a result of the use of the camera obscura.

One of the first to practice this new variety of a townscape was Carel Fabritius (1622-1654). He painted a small picture called *View in Delft* in 1652 which belongs to the National Gallery in London (not to be confused with Vermeer's *View of Delft*). The picture depicts the exterior of the choir of the Nieuwe Kerk with, to the left of it, a musical instrument-seller's stall and the water of the Oude Langendijk where Vermeer later lived. This canal has since been filled-in. The town hall of Delft and the south side of the Markt can be seen in the background and the houses of the Vrouwenregt on the right-hand side. The second house from the right still stands, the other houses were rebuilt later.
The remarkable perspective in Fabritius' painting has often been subject to discussion. The painting may have been made for a perspective box as a kind of topographic peepshow. Fabritius probably made use of a camera obscura in his painting, a device also used by Vermeer. His painting is often associated with Vermeer's work. He was ten years older than Vermeer. Before settling on the Oude Delft in 1650 he had worked at Amsterdam, where he was

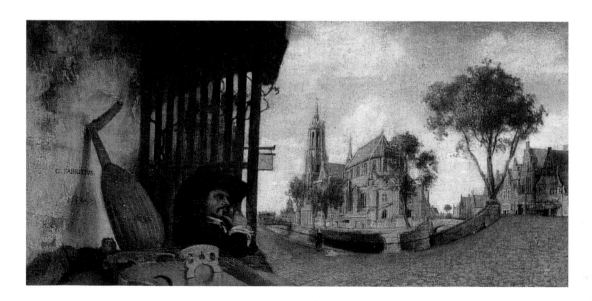

The view of the Nieuwe Kerk from the corner of the Oude Langendijk and the Vrouwenregt. The situation which Fabritius recorded has changed now. The Oude Langendijk has been filled-in and most of the fronts of the Vrouwenregt have been altered over the years.

apprenticed to Rembrandt. Fabritius was killed in the powder explosion of 1654. There is a poem by Arnold Bon, published in 1667 which commends Vermeer as successor to Fabritius after whose death "he followed him in mastery" (meesterlyck betrad zyne pade). This poem is sometimes taken as proof that Vermeer served his apprenticeship with Fabritius, but this is not probable. Fabritius enrolled with the Delft guild of St. Luke in October 1652, fourteen months before Vermeer and he would have been allowed to employ apprentices from then on. Vermeer could then only have spent the last year of his apprenticeship with Fabritius. But Vermeer was certainly impressed by the work of Fabritius. An inventory of Vermeer's estate made after his death showed that he owned three paintings by Fabritius.

The house of Pieter de Hooch

The artist Pieter de Hooch (1629-after 1684), who settled in Delft about 1652, had a strong influence on Vermeer's artistic development. He joined the guild of St. Luke in 1655. His own work was hardly influenced by the Delft style of painting during his first years in Delft, but from 1658 there is a noticeable change in his style. He began to paint interiors with people in them instead of dark guard-room scenes. His mastery of perspective and superb depiction of an environment, accurately diffusing the light inside it, place De Hooch's paintings from the period 1658-1660 among the very highest in Delft painting.

De Hooch's dimensional effects and registration of light had a decisive influence on the development of Vermeer's work after 1658. There is one clear difference between them: whereas De Hooch concentrated on the position of his figures in a space, Vermeer was interested in portraying people absorbed in what they were doing. He surpassed De Hooch in his austere composition and greater attention to figures and objects in a room

Pieter de Hooch's house is said to have stood behind the Oude Delft on the site where the monastery of St. Jerome's dale once stood in the sixteenth century. The monastery was dissolved in 1536 after the fire in Delft, although services were still held in the chapel until 1573. Nextdoor to the house at 161 Oude Delft is St. Jerome's gate, the entrance to the site. Two of De Hooch's paintings, both from 1658, show a courtyard with an archway and a stone above it inscribed in gothic lettering.

The inscription refers to the long-gone monastery and reads:

Come into the dale of St. Jerome
if ye would find patience and forbearance,
for we must first go down
if we would be uplifted 1614

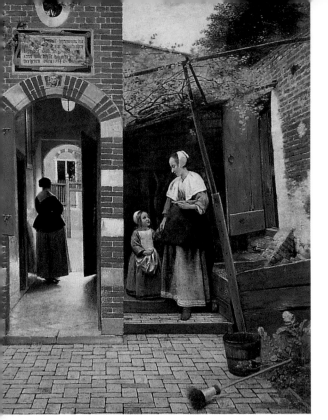

other side of St. Jerome's gate. Unfortunately it cannot be seen from the street. These two paintings, which portray what may be St. Jerome's gate, have led to the assumption that De Hooch's house stood on the site of the former monastery. At the sixtieth anniversary of the Delft students' union Sanctus Virgilius in 1958, a bronze plaque made by the sculptor H.J. Etienne was duly placed on the front of 161 Oude Delft. But it is highly doubtful that De Hooch really lived here. On his marriage to Jannetje van der Burch in 1654, he gave his address on the marriage certificate as the Binnenwatersloot. The archway on both the paintings differs from the situation of St. Jerome's gate as it was in the seventeenth century. De Hooch may have taken the liberty of modifying the scene.

Pieter de Hooch, Courtyard with a woman and child, *1658.*
London, The National Gallery.
Views through an archway into depth are a characteristic feature of De Hooch's work. Such views are also seen in Vermeer's oeuvre. The stone above the archway is like the one at St. Jerome's monastery. Pieter de Hooch may have painted St. Jerome's gate in this picture.

"dit is in Sint Hieronimusdaelle
wildt u tot pacientie en lijdtsaem-
heijt begeeven
wandt wij muetten eerst daellen
willen wij worden verheeven 1614"

The stone still exists and was originally built into the house at 157 Oude Delft. Today the stone is at the rear of 159 Oude Delft on the

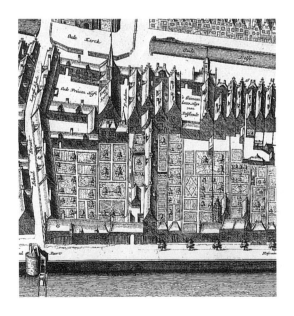

The memorial stone of the long-gone monastery of St. Jerome's dale, 1614.
The inscription on this stone, which has been depicted on two paintings by Pieter de Hooch, invites the reader to spare a thought for the vanished monastery. The stone is now in the first-floor wall at the rear of number 159 Oude Delft.

161 Oude Delft.
The conclusion was drawn that Pieter de Hooch lived at 161 Oude Delft because he painted two pictures which may possibly portray St. Jerome's gate.

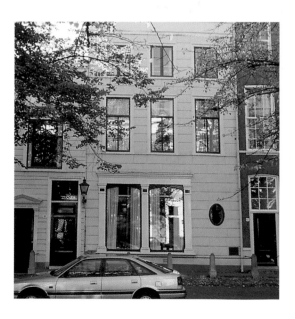

The house of Pieter de Hooch, a detail from the Figurative Map, 1675-1678.
Delft record-office.
Pieter de Hooch is supposed to have lived on the Oude Delft next to St. Jerome's gate, which led to the houses on the site of the former monastery of St. Jerome. The gate is a narrow opening between the houses of which only the backs are visible. Pieter de Hooch may have lived in the house on the left of the gate.

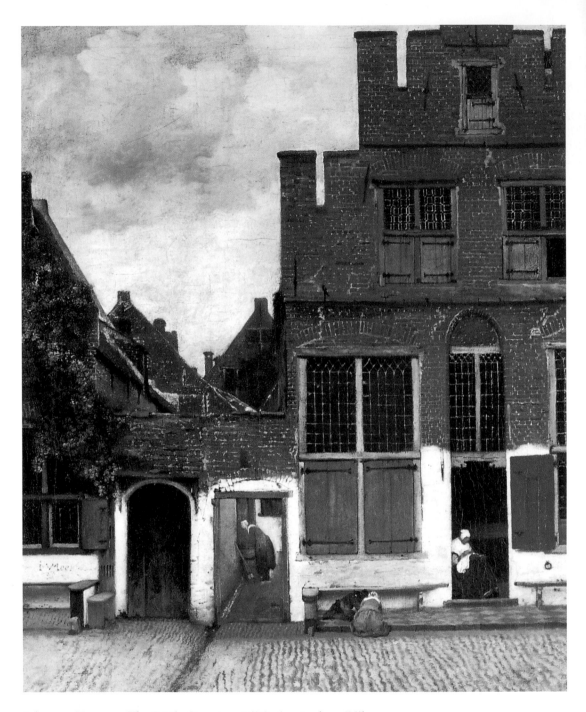

Johannes Vermeer, The Little Street, *c. 1658. Amsterdam, Rijksmuseum.*
This painting shows the fronts of two houses by a canal in Delft.
There are several theories as to the place where the houses could have stood.

6 Where was Vermeer's Little Street?

The painting

One of Vermeer's most famous works is *The little street*, which was donated to the Rijksmuseum in 1921 by the oil magnate Henry W. A. Deterding, to celebrate his twenty-fifth anniversary as director of the Royal Dutch Petroleum Company. The painting was dated on the basis of stylistic analysis about 1658. An auction catalogue of 1696 reveals that Vermeer painted another similar picture. It mentions a *View of a House in Delft* and a *View of several Houses. The little street* is usually identified with the first of these works.

The little street portrays parts of two facades in Delft, seen from a slightly raised viewpoint. A woman sits in the doorway of the house on the right, bent over her embroidery or lacemaking. Two children are absorbed in play on the chequered pavement in front of the house. Vermeer had originally painted a fifth figure by the open archway.

We can only see a small part of the house on the left. The top of the roof slopes steeply, becoming less steep by the dormer window. A roof of this kind with a kink in it indicates that the house has a side room.

There are two triangular gables in the background of the painting. The house behind the left-hand gable, to which the closed archway seems to lead, must be very big. The gable on the right, further back, is probably the back of a house facing onto a canal running parallel.

The painting evokes a serene atmosphere, with people quietly engaged in everyday activities. Sewing and cleaning the house were considered examples of work for virtuous women in the seventeenth century, and so was childcare. The grapevine against the house on the left, which has been associated with loyalty, love and marriage since antiquity, may be an allusion to this. The figures in the painting are secondary to their environment. This can be seen in the perfectly accurate depiction of the bricks and the vegetation, while the face of the woman in the doorway is unrecognizable. The mainly blue colouring of the vine is caused by oxidation of the yellow component in paint which was originally green. This is also the case with the trees in *View of Delft*.

The two archways connecting the houses to each other catch the eye in this painting. Whatever is behind the door of the archway on the left remains hidden from view. It probably belonged to the house on the left, or it may have led to the buildings behind the two houses. The archway on the right is open, allowing us to see into the courtyard. Peep-through views into depth like this are often to be seen in the work of Pieter de Hooch. The way in which Vermeer accentuated the bricks by drawing white lines of varying thickness along a reddish brown foundation is a technique which he borrowed from De Hooch, who also used it. A maid is at work in the courtyard by a rain tub. A little gulley in front of the tub is glistening with water. The fact that the gulley runs through the paving indicates that the houses are situated along a canal. The incidence of light in the painting suggests that the canal ran from east to west and that the house stood on the north side of the water.

The house on the right, of which we can see most of the facade, has some architectural features indicating that it was built before the town fire of 1536. For instance the construction of the facade, the high recessed alcove and the crenellated steps of the stepped gable. The many cracks, patched up here and there, also reveal the ripe old age of the house. The accurate reproduction of the brickwork and the cracks in places where they are to be expected constructionally, indicate that Vermeer chose an existing location to start with.

Then again, Vermeer seems to have made several adjustments to the facade. The doorway of the house on the right is not in the centre but slightly to the left, so that the entrance is nearer to the left window than to the right window. An explanation for this could be that there was a side room in the right-hand part of the front, separated from the rest of the house.

The underside of the window frame on the right of the first floor is a little higher than the one on the left, making the shutter on the right-hand window shorter than the other two shutters. The same applies to the two windows on the ground floor. Moreover, the shutter on the window to the right of the door is narrower than the two shutters of the left-hand window. This would mean that the window frame on the right is smaller than the one on the left.

The thin sidewall of the house on the right is also remarkable. The windows are topped by half-moon arches which conduct the weight of the facade downwards on a slope. This causes lateral pressure on the wall next to the window frame. The outer wall of the house on the right is of single-brick thickness, too narrow to withstand the horizontal load adequately. The house would need a timber frame to support this. Since Deterding made his donation, historians and art historians have turned their attention to the question where in Delft the houses in the painting must be located. Some presumed that Vermeer had a particular reason for painting the houses on *The little street*. But there is no evidence to support this. So many Delft scenes were painted during the seventeenth century, but hardly ever with a reason for choosing a particular location. It may have been commissioned by the owner, Pieter van Ruijven, so that the houses in the painting are not connected so much with Vermeer, as with his patron.

An astonishing amount of research has been carried out during this century into the possible location in Delft of *The little street*.

Although most of the resultant theories had to be rejected at a later stage, they are interesting enough to be recorded here. Seven theories were put forward of which three still stand: 24-25-26 Nieuwe Langendijk, 19-20 Voldersgracht and the recent ideas concerning 21 Voldersgracht. The other four have been rejected due to incorrect interpretation of the facts.

25 Oude Langendijk

The Delft municipal archivist mr. L.G.N. Bouricius was one of the first to devote himself to the location of *The little street*. In 1922 he put forward the theory that Vermeer had painted his house on the Oude Langendijk and that the two archways stood where the Molenpoort was (now Jozefstraat). Vermeer would then have painted *The little street* from the rear of one of the houses on the Markt. The perspective in the painting reveals that the artist's viewpoint was one and a half metres above ground level.

The houses on the Markt have a low-lying kitchen by the water at the rear, with a room over it above ground level, but below the first floor: in short, this must have been the artist's viewpoint.

But Bouricius' theory does not fit the facts. Until the 'sixties it was always thought that this house stood at the west corner of the Oude Langendijk and the Molenpoort (now Jozefstraat), where number 25 now stands. Research in the archives has revealed in two different ways that Vermeer's house stood on the other side, the east side of the Molenpoort and not on the south side like the houses in the picture. It also appears from the inventory of 1676 that his house must have been much bigger than the premises at number 25.

Apart from being the wrong locality for Vermeer's house, old maps of Delft show that there were never two archways side by side on this spot. That would have been

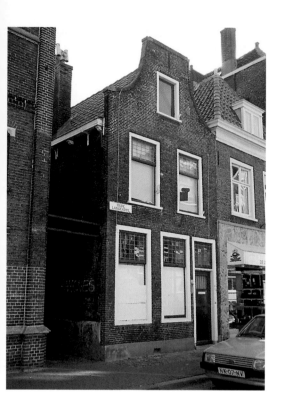

most unlikely because the Molenpoort was a road linking the Burgwal to the Nieuwe Langendijk, while the two archways in the painting clearly have no such purpose.

1 Spieringstraat

In his book about painting in Delft of 1948, the Delft journalist J.H. Oosterloo suggested the southern corner of the Spiering straat with the Vijverstraat as a possible location for Vermeer's painting as he saw some likeness to it. The situation certainly resembles *The Little street*, but the Spieringstraat was not a canal, the houses are on the west side instead of the north side and the house is not old enough either so that Oosterloo's theory becomes most unlikely.

25 Oude Langendijk
This house was long considered to be Vermeer's home. It was pronounced in 1922 that this building was the location of the painting The Little Street.

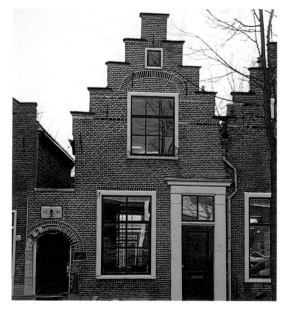

47 Achterom
This building is also associated with The Little Street. *At first sight it is very like the house in Vermeer's painting, but a closer look reveals that its front is much smaller.*

1 Spieringstraat.
As a result of a superficial likeness, this house on the Spieringstraat was connected with Vermeer's painting in 1948. But the house is of a later date than the painting.

21 Voldersgracht

In his book on Vermeer of 1950, the Dutch art historian P.T.A. Swillens suggested that Vermeer may have painted *The little street* from the back of the Mechelen Inn, his parents' home on the Markt which faced onto the Voldersgracht. The houses surrounding the Markt have an upper room at the rear so that the raised perspective would fit in any case. According to Swillens the Home for old men and women stood on that site on the Voldersgracht and it was pulled down in 1661 to be replaced by the new accommodation for the guild of St. Luke. This was in the same period that Vermeer painted *The little street* and Swillens thought that Vermeer wanted to record the scene before it was demolished. The building on the right of the painting would be the old people's home and the two women were inmates. In that case the archway on the right in the painting disappeared during the

renovations, while the left-hand archway can still be seen on the drawing made by Abraham Rademaker in about 1700. Swillen's interpretation was severely criticized as soon as his book was published. Firstly, only the old men's home stood on the Voldersgracht; the old women's home was in the Papenstraat, now the 'Huyse van St. Christoffel'. Secondly, the old men's home was not pulled down as Swillens thought, but renovated. It has often been assumed in literature concerning Vermeer that he had his studio in his parents' house. This could be true, but there is no evidence for it. Vermeer's studio could just as well have been in the house of his mother-in-law on the Oude Langendijk, where the artist and his family were living in 1660, and perhaps even earlier. A fourth argument against Swillen's theory is the fact that the house on the right of Vermeer's painting almost certainly dates from before the town fire of 1536. This fire, which reduced a large part of Delft to ashes, probably destroyed the houses on the Voldersgracht. A town plan of Delft painted after the fire shows the extent of the damage. There is nothing left of the houses on the Voldersgracht according to this painting, but we must add that the damage shown in the plan may have been exaggerated. Archeological research revealed that the damage was not so great as the painting suggests. However, as the Voldersgracht was at the centre of destruction, the houses on this canalside may well have disappeared. It is obvious that the houses painted by Vermeer were in another part of the town.

22 Vlamingstraat

After attending a lecture on Vermeer in 1957, the owner of the premises at 22 Vlamingstraat at the time, felt sure that he was living in the house painted by Vermeer in *The little street.* The longer he looked at the painting, the more convinced he became, and when he also learned that Vermeer's mother lived in the Vlamingstraat during

her last years, this decided the matter for him. The woman in the archway could be no other than Digna Baltens. He had forgotten that Vermeer's mother lived in Mechelen House on the Markt until 1659, while the painting was dated about 1658.

The house in the Vlaming street certainly bears a strong resemblance to the house in *The little street*. It housed an inn called the "Hof van Holland" in the eighteenth century. There is a picture of the inn on a late eighteenth-century brass tobacco tin in Stedelijk Museum The Prinsenhof. The layout of the frontage, the shape of the windows and the archway on the left correspond with the painting. The house even stands on the north side of the canal, but the theory is undermined by the absence of a double archway. It is precisely this detail in combination with the other conditions which narrows down the number of possible locations in Delft.

22-24-26 Nieuwe Langendijk

Archeological and architectural research took place in three houses on the Nieuwe Langendijk in 1982. The information which was unearthed during this research also concerns *The little street*. Based on this, the municipal archeological historian W.F. Weve put forward the theory that Vermeer had chosen this location for his painting. This part of the Nieuwe Langendijk meets the basic demands: the houses are situated on the north side of an east-west running canal, on the edge of that part of town which was spared by the fire of 1536. It is quite possible that there were still some late-medieval houses there in the seventeenth century.

22 Vlamingstraat
The 'Hof van Holland' Inn was pulled down at the beginning of the twentieth century. The archway is still there, next to the house at number 22.

The tobacco tin showing the 'Hof van Holland' Inn, c. 1795.
Delft, Stedelijk Museum Het Prinsenhof.
The facade of the 'Hof van Holland' Inn on the Vlamingstraat is engraved on the lid of this late-eighteenth-century brass tobacco tin.
The inn with the archway next to it resembles the house on the right of The Little Street.

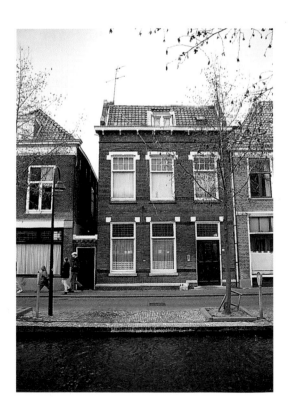

The three houses on the Nieuwe Langendijk were pulled down in 1982. Number 26, dating from the second half of the fifteenth century was the most easterly of the houses. It was of the same construction and proportions as the house on the right of the painting. Number 22 corresponds with the part under the steeply pitched roof of the house on the left, while the house at number 24, dating from the first half of the nineteenth century, stood on the site of the two archways and the side room of the house on the left of the painting. There was a large hall behind numbers 22 and 24

22 - 26 Nieuwe Langendijk before demolition in 1982.
Delft record -office.
Several of the premises on the Nieuwe Langendijk were pulled down in 1982 architectural and archeological research carried out at the time provided a great deal of infomation which also applied to the houses in The Little Street. *According to the theory put forward then, number 22 corresponded with the left-hand part of the house on the left of the painting. The house at number 24 would have stood where the two archways and the extension of the house on the left are, and the house at number 26 would have been the house on the right in the painting.*

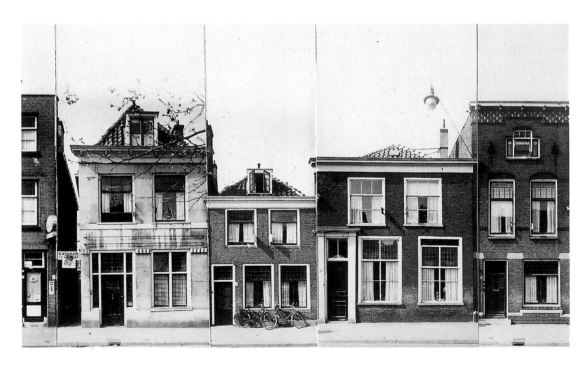

dating from the first half of the fifteenth century with the dimensions and layout corresponding with the house on the left in the background of the painting.

It was a great disappoinment during the excavations that the soil underneath number 24 had been seriously disturbed. The sewer and a shallow cellar had churned up the soil to a depth of half a metre below ground level. In addition the excavation of the building had to be carried out in so short a time that it was impossible to determine whether there had been two archways on this spot in the seventeenth century. It was sad that the soil research at number 24 failed to produce proof of this theory. All the same, the archeological research and finds fitted in with Weve's theory, making it more plausible. This is remarkable enough in itself because there are so few places in Delft which meet all the demands made by the painting regarding its location. Moreover, this is the only theory which takes the houses in the background of the painting into account. This is neglected in all the other hypotheses on *The little street*. Our hope is now concentrated on research into the residential history of the houses on 22-26 Nieuwe Langendijk, which could reveal that Vermeer had some kind of connection with this location. Dubious as this may be, it is the only possibility of supporting the argument for the Nieuwe Langendijk. The problem is that research into the residential history of an old building is an extremely accurate and painstaking activity with no guarantee that it will eventually yield the names of former inhabitants. No one has taken it upon themselves to carry out research of this kind on the Nieuwe Langendijk as yet.

22-26 Nieuwe Langendijk
After they had been pulled down, appartments were built on the site of the houses which may have been the subject of The Little Street.

19 and 20 Voldersgracht

A fresh attempt to locate *The little street* on the Voldersgracht was made by Mrs. M.A. Lindenburg in 1993. Mrs. Lindenburg followed up Swillens theory which held that Vermeer painted the houses on the Voldersgracht from Mechelen house, about one and a half metres above street level, but she located the houses slightly more to the west at numbers 19 and 20. This means that the house on the left of Abraham Rademaker's drawing of the guildhall, is the house on the right in the painting by Vermeer. Both houses share the same arrangement of the facade with the characteristic high window over the front door. The two archways in the painting would still be in existence. The archway on the right actually leads to a courtyard while the one on the left is now built into the facade of number 19, but it does not belong there and until recently it still had a paved surface. Another interesting detail is that the artist Cornelis Daemen Rietwijck lived at number 20 and gave lessons in drawing, mathematics and other subjects there.

19 and 20 Voldersgracht
Where these two houses meet there are three
doorways, of which the middle one is part of
a shop-window. The two openings on the right
could be the archways in Vermeer's painting.

Perhaps Vermeer learned the rudiments of
drawing from him.
However attractive Mrs. Lindenburg's
theory may be, there are a few snags to it.
Vermeer could see the two houses from the
rear window of the Mechelen Inn, but he
would not have been able to see into the
archway. This is only possible from the back
of the premises at 50 the Markt, two houses
further along. In that case Vermeer must
have adjusted the perspective. At this point
an inconsistency crops up in the theory,
which assumes that Vermeer's viewpoint
must have been above street level.
Supposing that Vermeer adjusted the
perspective horizontally, he could have
done the same vertically. Moreover, if
Vermeer wanted to paint the view from his
studio he would have been more likely to
choose the houses straight in front of it, in
this case the old men's home, than the

houses which he could only see from the
northeast corner of his studio. A third
argument against Mrs. Lindenburg's theory
is that the fire of 1536 most probably
destroyed the houses on the Voldersgracht,
while the house on the right of *The little
street* is almost sure to have been built before
the fire. Mrs. Lindenburg's theory turns out
to be less plausible than it seems at first
sight.

21 Voldersgracht reviewed

In the catalogue of the Vermeer exhibition of
1995/1996 in the National Gallery in
Washington and the Mauritshuis in The
Hague, the authors Arthur Wheelock and
Ben Broos suggest that Vermeer may have
composed the houses in *The little street* from
elements of several different buildings. Just
as Pieter de Hooch combined various pieces
of architecture into a seemingly realistic
environment in his paintings of Delft
courtyards, Vermeer could also have
composed the houses in his painting from
separate elements. De Hooch's method was
easy to trace because he painted several
comparable works in which the same
constructional elements were used
continually, in a different context. *The little
street* is unique within what was preserved
of Vermeer's oeuvre, so that no one
considered this possibility.
Both authors stress the asymmetrical
construction of the facade with shutters and
window frames of varying sizes to support
their theory. The fact that the houses in the
picture are only partly visible suggests that
Vermeer did not set out to paint an accurate
'portrait' of an existing house.
Wheelock and Broos try to discover what
Vermeer's main source of inspiration could
have been. They fall back on Swillen's idea
that Vermeer painted what he saw from the
back of the Mechelen Inn, again putting
forward 21 Voldersgracht. There are
drawings and prints of St. Luke's guildhall
which show a narrow entrance with an

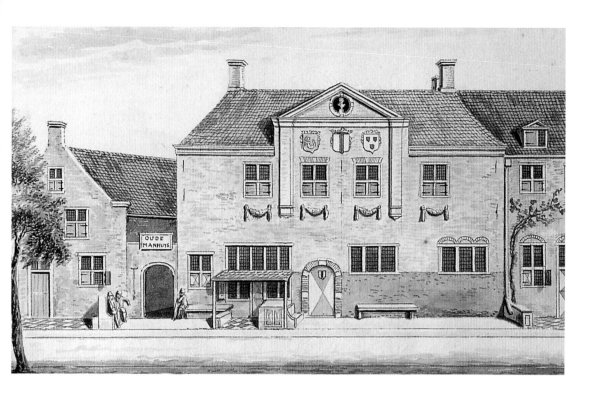

Abraham Rademaker, St. Luke's Guildhall,
c. 1700.
Delft record office.
According to Lindenburg's theory, the houses
which Vermeer painted may have stood to the
west of the Old Men's Home. The house on the
left of the drawing would then correspond with
the house on the right in The Little Street.

awning on the left. Next to this is a
mullioned window and an archway.
According to both authors, Vermeer took
this part of the guildhall as the basis for *The*
little street, and the rest of the frontage in the
painting must have stood in another part of
the Voldersgracht. However plausible this
theory seems, it is not very probable. The
precise brushwork and the sound
construction of the facade with all kinds of
details, such as the chimney just visible
between the two merlons on the right, make
it far more likely that Vermeer painted an
existing house and that he modified some
parts of it to improve the composition. He
worked along similar lines in the *View of*
Delft.

7 The View of Delft

The location of View of Delft

Vermeer's most famous painting is without a doubt the monumental *View of Delft*, which he probably painted in, or soon after 1660 and which has belonged to the Mauritshuis, The Hague since 1822. It portrays the profile of Delft, seen from the southwest, in the light of the early-morning sun.
There are two town gates on the other side of the water. The one on the left is the Schiedam gate with a clock in the roof gable indicating the time between seven o'clock and half past seven. The clock was used by ferry-boats leaving the harbour to go to Rotterdam, Schiedam or Delfshaven. The men and women in the foreground on the left of the painting are waiting for the tow barge to leave its moorings.
The other gate is the Rotterdam gate where members of the seamen's guild used to meet. The building consisted of two parts. The gate itself, beautifully ornamented on the town side, can be seen on the right of the tower of the Nieuwe Kerk. Next to it is a watchpath which ends in the outer gate with two small round turrets. The Rotterdam gate had kept much of its late-medieval character in the seventeenth century. The drawbridge

Johannes Vermeer, View of Delft,
c. 1660-1661.
The Hague, Mauritshuis.
Vermeer's townscape displays the dignity and pride of a prosperous town in the seventeenth century.

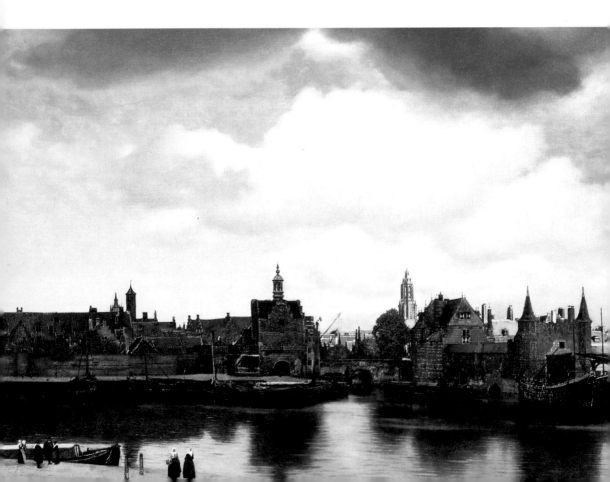

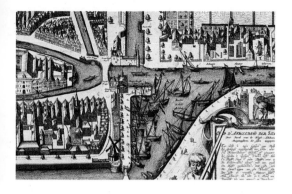

*The Schiedam and Rotterdam gate, a detail from
the* Figurative Map, *1675-1678.*
Delft record office.
*The Armamentarium, flanked by water on three
sides, stands to the left of the two town gates.
The tower of the Parrot brewery is seen below it.
Both buildings can be found in the* View of Delft.

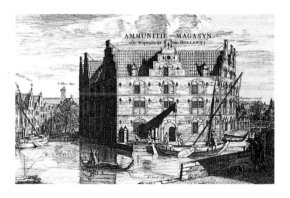

Coenraad Decker, The Armamentarium,
c. 1680.
Delft record office.
*The stepped-gable of the Armamentarium, the
arms depot of the States of Holland and West
Friesland, can be seen in the* View of Delft.
*The cannons are piled up in front of the building.
To the left of it are East India House, belonging
to the Delft Chamber of the Dutch East India
Company, and the orphanage housed in the
former Convent of St. Barbara.*

by the outer gate opens onto the east bank of
the river Schie.
The Schiedam gate also had a watchpath
with an outer gate originally. There was a
triangular bastion by the outer gate,
surrounded by water and linked to the
Schiedam gate by a drawbridge. This
bastion was constructed in 1573 when the
fortifications were modernized. In 1614 it
was dug up again, creating a triangular
harbour called the Kolk. The outer gate and
watchpath of the Schiedam gate were also
demolished so that the building lost its
original status of town gate.
The spire of the Oude Kerk can be seen on
the left in the *View of Delft* with the slender
tower of De Papegaey (the parrot) brewery
to the right of it. The high, elongated roof to
the left of the painting is also part of this
huge brewery. The town wall runs alongside
the water of the Kolk, with some of the
facades of houses in the Kethelstraat rising
up behind it. The red roof of the
Armamentarium is visible above the bridge
of the Rotterdam gate. Built in 1602, the
Armamentarium was the armoury of the
States of Holland and West Friesland. To the
right of the Armamentarium is the tower of
the Nieuwe Kerk, where members of the
House of Orange-Nassau lie buried. The fact
that the tower is bathed in bright sunlight
may be a subtle expression of support for
the stadholder and his family.
Vermeer's painting radiates deep
tranquility. Just as in *The little street*, the
human figures are unobtrusive in their
surroundings. X-ray photographs and
restoration work in 1994 revealed that
Vermeer originally added a seventh figure
to the painting, which he later painted over.
In contrast with most other seventeenth-
century townscapes there is hardly a sign of
human activity. In this respect Vermeer's
painting is a misrepresentation of reality as
the Kolk was a busy harbour in the
seventeenth century. The Schie canal linked
Delft with Rotterdam, Schiedam and
Delfshaven: the latter had served as the real

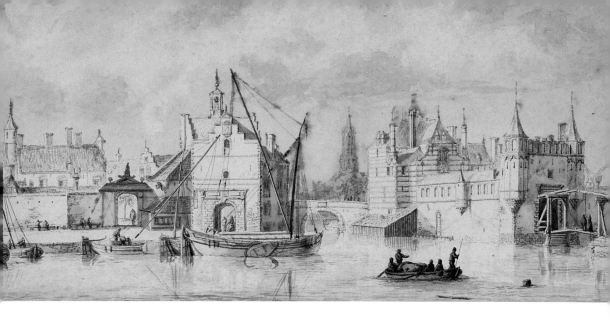

Abraham Rademaker, The Schiedam and
Rotterdam gate at Delft, *c. 1700.*
Delft, Stedelijk Museum Het Prinsenhof.
Abraham Rademaker drew the town gates about
half a century after Vermeer. The situation has
hardly changed, but the atmosphere is completely
different. Vermeer created a harmony in the
View of Delft *by means of his use of colour and*
emphasis on the horizontal lines, which is
missing in this work by Rademaker.

harbour of Delft since 1389 and it was
controlled by Delft town council. The Delft
Chamber of the East India Company had its
shipyards here, its East Indiamen were built
here and its ships moored here on their
return to the Republic from the East with
their precious cargo. Barges carried the
goods from Delfshaven to the Kolk.
Vermeer may have made use of the camera
obscura when he painted *View of Delft*. This
device was already known in Antiquity, but
it was first used as an aid in the depiction of
topographical scenes in the sixteenth
century. A scene was projected onto a piece
of paper or a plate of glass via a lens, as in

photography, and the artist then copied the
result. The camera obscura produces certain
effects, such as a blurred perspective,
intensified light and distorted reflections of
light, particularly at the edges. But the role
of the camera obscura in Vermeer's work
may not be overestimated. He certainly did
not trace the projected image, but he may
have used camera obscura to achieve special
effects of light and colouring.
P.T.A. Swillens, who also turned his
attention to the locality of *The little street,*
was so impressed by the detailed depiction
of the situation around the Kolk that he was
sure the picture could only have been

painted outside on the site. As the Hooikade was nowhere raised and the viewpoint of the painting is considerably above street level, Swillens was convinced that Vermeer must have worked from a building. A town plan of Delft from 1649 shows that the Hooikade was not yet built-up in mid-seventeenth century, except where the Kolk enters the Schie, and that is the exact viewpoint of the painting. There was a little house on that very spot. According to Swillens, Vermeer must have taken up his position on the first floor here and then painted the situation from nature. There is no sign of this house on the Figurative Map made between 1675 and 1678 but it shows that there were several houses on the Hooikade. Vermeer could also have worked from one of these premises.

Swillens conception is not very plausible. There is not a single seventeenth-century artist who is known to have painted directly from nature. This was not done until the nineteenth century when the French impressionists were the first to set up their easels in the open air. Previously paintings were always completed in the artist's studio, sometimes based on sketches made earlier. Moreover, almost all seventeenth-century townscapes and landscapes were made from a higher viewpoint. Artists were most skilful in adapting the perspective in those days. Comparison with other drawings and prints of the two gates shows that Vermeer adjusted the situation in the painting. The bridge over the Oude Delft between the two gates slopes upwards slightly in some of the drawings while the bridge in Vermeer's painting is perfectly horizontal. The tower of the Nieuwe Kerk is slightly lower in relation to the other buildings than it is in reality. The houses to the left of the Schiedam gate have been raised in comparison with those on the right. Combined with the red and brown colouring which dominates this part of the painting, a more or less continuous image emerges on the left-hand side, in which details such as the passage through

the town wall next to the Schiedam gate can hardly be seen. The reason for these modifications could be that Vermeer did not want to disturb the horizontal scheme. The distance between both gates also seems to have increased for reasons of composition. X-ray photographs of the painting also reveal that Vermeer modified the reflection of the outer gate on the right.

The two small turrets were completely reflected in the water originally, but Vermeer later altered the reflection so that the tops of the two spires remain out of sight.

Vermeer's *View of Delft* is part of a long tradition of townscapes. Hendrick Vroom, Jan van Goyen, Daniel Vosmaer and Jan de Vos all painted their own versions of the Delft profile before him. They began by painting the north or west side of the town. According to the American art historian Alan Chong, Vermeer's decision to paint the town from the south may have been prompted by three events which occurred shortly before the picture was painted.

The explosion in 1654 of the powder magazine of the States of Holland and West Friesland devastated most of the northeast of the town. When Vermeer painted his *View of Delft* six years later, the town had largely recovered but there were still some signs of the disaster.

After the explosion the town council issued a ban on the construction or equipping of powder magazines in or near the town. But small depots were left in two parts of the town, with a modest supply for immediate use. One of these depots was housed in the Armamentarium, visible in the painting with the sun shining on its roof. Fire broke out in this building in January 1660. Although the fire was soon under control, the people of Delft were not at all happy with the situation.

In the same year as this fire there was another event in the south of town, (the subject of Vermeer's painting) which made a deep impression on the people of Delft.

David Philippe after Adriaen van der Venne,
The Arrival of Charles II at Delft, *1660.*
Delft record office.
Shortly before the View of Delft *was painted,*
the crown- prince of England,Charles II was
given an enthusiastic welcome in front of the
Schiedam and Rotterdam gate. This festive
occasion was captured in print.

Charles II of England, who had been living
in exile on the continent since the execution
of his father Charles I, heard when in Breda
on 8th May 1660, that the English parliament
had assented to his return to England. On
his way to The Hague he would be passing
through Delft and the town had prepared a
great reception for him near the brand-new
powder magazine of the Generality by the
Schie. Charles II arrived at the site on the
outskirts of town on the 25th May 1660. As
he was early there was no one there to meet
him and he decided to continue on his way
to Delft. The burghers of Delft, in great
haste, eventually met him by the Rotterdam
gate.
It would be going too far to link these three
events directly with Vermeer's townscape.
The destruction of the northeastern part of
the town had made Delft unattractive from

78

Isaak van Haastert, The Schiedam and
Rotterdam Gate, *c. 1770*
Delft, Stedelijk Museum Het Prinsenhof.
Isaak van Haastert painted both town gates over
a century after Vermeer. The watchpath of the
Rotterdam gate had been demolished long ago.

the traditional viewpoint, while this
important and festive occasion took place in
the southwest just before the *View of Delft*
was painted. Vermeer's masterpiece
displays the splendour of Delft, as
magnificent as ever in spite of the disaster.

The View of Delft seen from plein Delftzicht

There is little left of the splendour portrayed
by Vermeer in or soon after 1660. Both of the
gates and the town wall were pulled down
in the 'thirties of the nineteenth century and
the many stepped-gables in the painting

Hendrick Vroom, View of Delft from the west, *1615.*
Delft, Stedelijk Museum Het Prinsenhof.
Following the example of Hendrick Vroom,
Delft was usually painted from the west or north
in the seventeenth century. Vermeer was the first
to choose a viewpoint from the south side of the
town.

have been replaced by modern fronts in the meantime. Only the towers of the Nieuwe Kerk and the Oude Kerk have survived. The present spire of the Nieuwe Kerk dates from 1875 as the original wooden spire caught fire when it was struck by lightning three years earlier.
The busy road which now crosses the site of the fortifications evokes a completely different atmosphere from the serenity which distinguishes the *View of Delft*. It would be better to avoid 'plein Delftzicht' if you are in search of the quietude in Vermeer's masterpiece.

The 'Papegaey' (parrot) brewery

During the seventeenth century a brewery called The Parrot was housed on the site of the imposing building at numbers 15-21 on the Oude Delft. The building was one of the few private houses in Delft with a little tower, which can be seen on the left in the *View of Delft*.

This tower is sometimes mistaken for the one belonging to the former convent of St. Barbara on the Oude Delft. The building was in use as an orphanage from 1579 until 1911. The tower was probably built after the convent was destroyed in the town fire of 1536. It was not kept in repair after 1726 and it collapsed during a heavy storm in 1812. When the convent was restored in 1962 it was decided to rebuild the little tower. This was done with the tower in Vermeer's painting as a model, because the original construction was not clear. St. Barbara's convent was in fact too far away for Vermeer to see and the tower in the painting actually belonged to The Parrot.

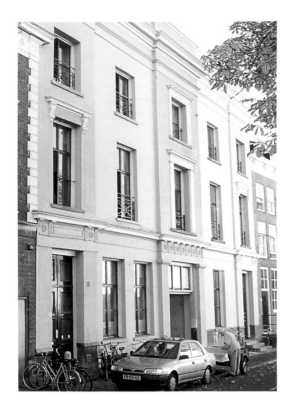

15-21 Oude Delft.
The Parrot brewery stood on the site of these large premises during the seventeenth century. Its tower can be seen in the View of Delft.

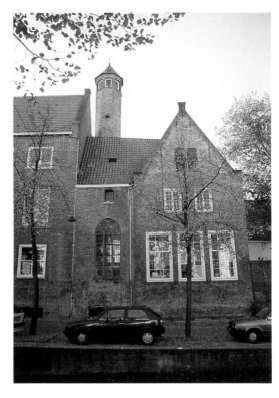

55-57 Oude Delft.
The tower of the former Convent of St. Barbara was reconstructed with the aid of the View of Delft in the 'sixties. In fact, the little tower in Vermeer's painting belonged to the Parrot brewery.

View of Delft.

8 The Death of the Artist

The 'Oude Kerk (the Old Church)

Vermeer was buried in the Oude Kerk, the oldest parish church in Delft. The church was first dedicated to St. Bartholomew, the patron saint of the founder of the church, Bartholomeus van der Made. Named after St. Hippolytus in 1396, a church founder and a martyr, the building was ordained for protestant worship from 1573 onwards.
The church was renovated and enlarged again and again over the years. The leaning tower is one of the oldest parts. It began to subside during construction, which was started in 1325. The builders kept their heads and corrected the subsidence by carrying on building in the perpendicular. The result was that the tower developed a kink.
The southern part of the nave is made of brick and dates from about 1370. The nave was also enlarged on the west side between 1425 and 1450, since when the tower has been enclosed on three sides. A third notable extension took place at the beginning of the sixteenth century: the northern transept, the Choir of Our Lady and the north chapel were built at the northeast side of the church. This part differs from the rest of the church in that sandstone was used instead of brick. The graves of celebrated people including the statesman Antonie Heinsius and the naval heroes Piet Hein and Maarten Harpertszn. Tromp can be found in the Oude Kerk.
Vermeer's mother-in-law, Maria Thins, bought a grave in the Oude Kerk in 1661. Although the church was used for protestant worship, catholics could also be buried there. It is written in Maria Thins' will that she did this to keep her funeral expenses down. Her original plan was to be buried in the St. Jan at Gouda. By purchasing her grave in Delft, she saved the fare to Gouda.
One of Vermeer's children was buried in the grave on 10th July 1667. This happened again in 1669 and again in 1673. He had already buried a child once before, in another grave. The names of the children are not given in the register of burials, so they must have died in early infancy. Fourteen years after Maria Thins bought the grave, her son-in-law Vermeer was also buried in it. The register of burials of the Oude Kerk records that he was buried on 16th December 1675. The coffin of the last of his children to die was placed on top of his coffin.
The artist's death may have been caused by the pressing financial problems which dogged him and his family. His widow wrote a petition to the Hof van Holland in 1677, for money to be released from his estate. In it she explains that as an art dealer, Vermeer was unable to sell the paintings in which he traded as a result of the war which had broken out with England and France in 1672, a year of crises for the Dutch. She writes "he was so laden with care for his many children and which he took so much to heart that it drove him to a frenzy, and from being alive and well the one day, within one and a half days he was dead." Vermeer had probably become so agitated by his hopeless situation that he suffered a fatal heart attack.
His brother-in-law Willem Bolnes also died a few months later and he was buried in the same grave.
The situation remained very bleak for Vermeer's wife and children after his death. The loans and gifts from her mother Maria Thins brought no lasting solution. Maria died in December 1680 and she was buried in the family-grave on 21st December. The grave was then full. Catharina and her children went to live in Breda after her mother died. In 1687 she visited her eldest daughter Maria, who married a silk merchant in 1674 and lived in the house called 'De Blauwe Hant' (the blue hand) on

Coenraad Decker, The Old Church, *c. 1680.*
Delft record office.
The Oude Kerk was founded before the Nieuwe
Kerk, but most of the building is of later date.
It was ordained for protestant worship as
from 1573.

the Verwersdijk. There she fell ill and she died soon afterwards. A note in the margin of the register of burials tells us that her coffin was carried by twelve bearers, an unusually high number. It is not (yet) known where Vermeer's widow was buried. The location of Vermeer's grave was long unknown. The Delft historian A. van Peer succeeded in locating it in 1968. The church wardens' accounts show that the grave purchased by Maria Thins in 1661 lay in the northern part of the church, the eighth grave in the second square. A square denotes a row of graves running from the wall to the nave. As this part of the church contained twenty-five rows of sixteen graves each, it was possible to single out the exact location of the grave. A memorial tablet commemorating the third centenary of Vermeer's death was unveiled by Burgomaster Oele in 1975. He vacuumed a layer of sawdust from the tablet, symbolizing the dust of ages. The remains of Vermeer and his family no longer lie under the stone. Most of the graves in the Oude Kerk have been cleared in the course of time due to the danger of subsidence. The grave of the renowned physicist Antoni van Leeuwenhoek (1632-1723) can also be found in the Oude Kerk. He was born a few days after Vermeer and their names happen to be on the same page of the register of births of the Nieuwe Kerk. He was appointed curator of Vermeer's estate after his death. Van Leeuwenhoek was buried in the Oude Kerk in 1723. The monument erected to him by his daughter in 1739 is a plain column with a medallion of the deceased on it.

The Oude Kerk.
The tower of the Oude Kerk began to subside
during construction. A kink developed due to
corrective measures. The top of the spire can be
seen in the painting View of Delft.

The Chamber of Charity

The Chamber of Charity was the municipal charitable institution which supported those inhabitants of delft in financial difficulties, with money, or in kind. This institution had been housed in a part of the Prinsenhof since 1614. The statue above the entrance in the Schoolstraat, which was probably made by Hendrick de Keyser, is a reminder of this. It was the custom in the seventeenth century when someone died, that the Chamber of Charity sent a chest to his house in which to collect the 'best garment' or a donation of equal value for the poor of the town.
The register of the Chamber reveals that no chest was sent to Vermeer's house when he died because, it reads "there is nothing to collect". These few words express the deplorable financial situation of Vermeer's family at the time of his death.

Vermeer's tombstone.
Vermeer was buried in the Oude Kerk on
16th December, 1675. At the memorial service
for the third centenary of his death, a tombstone
was placed on his grave.

The Chamber of Charity was directed by the masters of charity, an office which Vermeer's greatest collector, P.C. van Ruijven also held between 1668 and 1672.

Abraham Rademaker, The Chamber of Charity, *c. 1700.*
Delft record office.
The Chamber of Charity supported the poor of Delft. The institution was dependent on gifts. When a person died, the Chamber sent a chest in which to collect a donation for the poor. No chest was sent when Vermeer died, because he had so little.

Van Ruijven was a wealthy Delft man of leisure who had grown rich from inheritances and wise investments. He was a passionate art-lover who owned about twenty paintings by Vermeer.

Vermeer was on good terms with Van Ruijven, who lent the artist two hundred guilders in 1657, perhaps as an advance on one or two paintings. Maria de Knuijt, the wife of Pieter van Ruijven, made a will in 1665 in which a further five hundred guilders was bequeathed to Vermeer.

5 Schoolstraat.
There is a little statue of Charity above the entrance to the Chamber of Charity, which was probably made by the sculptor and architect Hendrick de Keyser. The two crying children were added later.

The house of Antoni van Leeuwenhoek

When Vermeer died, his widow Catharina Bolnes was left with many debts. As a result of the war with France and England in 1672, Vermeer lost much of his income from the sale of paintings. He was forced to borrow money which he had not yet repaid when he died. He owed the baker Hendrick van Buyten six hundred and seventeen guilders and six stivers which amounted to a three-year supply of bread. His widow paid this sum by selling two paintings by Vermeer: the *Lady writing a letter with her maid* and probably also *The guitar player*. Twenty-six paintings were transferred to the draper Jannetje Stevens, not Vermeer's own works but others which he, as an art dealer, had in his possession. Soon afterwards Jannetje sold these works to Jan Coelenbier, an art dealer from Haarlem, for five hundred guilders. These paintings probably constituted the bulk of Vermeer's stock.

To ensure that the remaining debts were also paid, a notary's clerk made an inventory of Catharina's belongings three months after the death of Vermeer. Just before this she visited a notary at The Hague to declare that she had given the painting *The Allegory of Painting* to her mother, together with the income from two rural estates. The transfer was a partial repayment of the money which she owed her mother. But this transaction was initially intended to keep some of her income and this particular painting by her husband, which she seems to have valued highly, from falling into the hands of the creditors. At the end of April 1676 Catharina petitioned the Hof van Holland for postponement of payment, which was granted. Catharina was then declared bankrupt and she relinquished Vermeer's estate to the creditors.

The aldermen of Delft had to appoint someone to administer Catharina's affairs. The chosen curator was the well-known physicist Antoni van Leeuwenhoek who had been chamberlain of Delft aldermen since

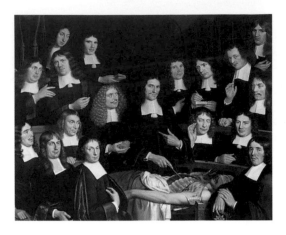

Cornelis de Man, The Anatomy Lesson of
Cornelis 's-Gravesande, *1681.*
*Delft, Stedelijk Museum Het Prinsenhof, on loan
from the Oude and Nieuwe Gasthuis at Delft.
The central figure is dr. Cornelis 's-Gravesande,
the neighbour of Antoni van Leeuwenhoek,
who taught him the rudiments of anatomy.
Although he was not a member of the Delft guild
of surgeons, Van Leeuwenhoek is in the painting,
on the right behind dr. 's-Gravesande, with his
hand on his stomach.*

1660, a combination of warden and bailiff.
In his spare time Van Leeuwenhoek made
improvements to the microscope through
which he discovered the existence of red
blood corpuscles, bacteria and spermatozoa.
His famous contemporary, the Delft medical
practitioner Reinier de Graaf (1641-1673)
introduced Van Leeuwenhoek to the Royal
Society in London. Van Leeuwenhoek kept
this society informed of his microscopic
discoveries in more than two hundred
letters, with the result that he was made a
fellow of the Royal Society in 1680.
Van Leeuwenhoek's interest in lenses and
Vermeer's use of the camera obscura are
sometimes interpreted as a sign that the two
men knew each other. If that were true then
the man in the paintings *The astronomer* and
The geographer could be Van Leeuwenhoek,
as he also studied mathematics, navigation
and astronomy. But the way in which Van
Leeuwenhoek administered the estate and
his conflicts with Vermeer's widow and
mother-in-law, suggest that he was more
inclined to side with the creditors than with
Vermeer's family. Van Leeuwenhoek was
planning to organize an auction sale on 15th
March 1677 in St. Luke's guildhall, to sell the
twenty-six paintings in Vermeer's estate. He
had reclaimed them from the draper
Jannetje Stevens by means of a lawsuit. The
picture *The Allegory of Painting* was also to be
put up for auction, to the great displeasure
of Maria Thins who lodged a protest against
this. It is not known whether the auction
was actually held.

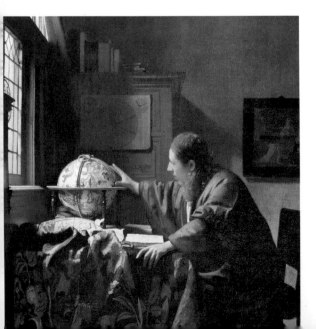

Johannes Vermeer, The Astronomer, *1668.
Paris, The Louvre.
Vermeer may have portrayed Antoni van
Leeuwenhoek in this painting. Van Leeuwenhoek
also studied astronomy and he resembles the
scholar in the painting. He was also about the
same age as the man portrayed when Vermeer
painted the picture.*

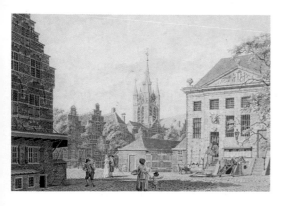

Isaak Ouwater, View of Delft by the
Meat-market and the Fish-market, *1785.*
Delft, Stedelijk Museum Het Prinsenhof.
In this watercolour by Isaak Ouwater, the houses
of the Hippolytusbuurt can be seen in the
background. The last house on the left of the
row belonged to Antoni van Leeuwenhoek.

Van Leeuwenhoek makes his last
appearance as curator in 1682. The guardian
of Vermeer's children gave him permission
to sell two bonds from the estate, possibly to
pay the last outstanding debts to creditors.

Van Leeuwenhoek bought the house 'Het
Gouden Hoofd' (the golden head) in the
Hippolytusbuurt in 1654. The landscape
artist Pieter Groenewegen, who had been on
good terms with Vermeer's father, lived in
this same house in 1633. Van Leeuwenhoek
had to borrow five thousand guilders to
finance the purchase. He established himself
as a cloth merchant and set up a drapery on
the ground floor. Van Leeuwenhoek made
most of his discoveries in his study in Het
Gouden Hoofd, where he received many
important guests from at home and abroad
including the Tsar, Peter the Great. The
building was later demolished and the
house in its place now dates from the
nineteenth century. A plaque in the wall
commemorates his house.

7 Hippolytusbuurt.
A nineteenth-century house now stands on the
site of Van Leeuwenhoek's house.

The 'Gulden ABC' printing-office

Vermeer's work was also highly esteemed after his death. One of the largest collections of his work belonged to the Delft printer Jacob Abrahamsz. Dissius, owner of the Gulden ABC printing office on the Markt. Dissius was married to Magdalena van Ruijven, the daughter and only heiress to Pieter Claesz. van Ruijven, the wealthy burgher of Delft who bought many paintings directly from Vermeer during his lifetime. On Magdalena's death in 1682 the collection became the property of her husband. An inventory was made of all the pictures in his possession which included as

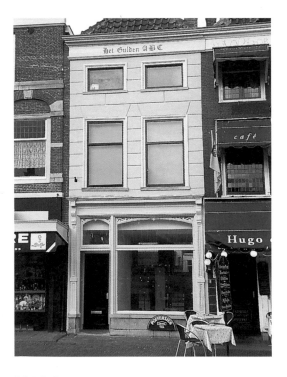

32 Markt.
The largest collection of paintings by Vermeer belonged to Jacob Dissius. He was a well-known Delft printer and he lived on the Markt in the 'Gulden ABC House'. After Dissius' death his collection was sold at auction in Amsterdam.

many as twenty paintings by Vermeer, without mentioning their titles.
Jacob Dissius died in October 1695 and his collection of paintings was sold at auction in Amsterdam six months later. There were twenty-one Vermeers in the collection then, one more than was noted in the inventory made after the death of Magdalena. The paintings are described and mentioned by name in the auction catalogue. Famous paintings such as *The Little Street*, *The Lacemaker* and the *View of Delft* belonged to Jacob Dissius and graced his home at number 32 the Markt. The building had a different aspect in Vermeer's day as its present front dates form the early nineteenth century.

The statue of The Milkmaid

The statue of *The Milkmaid* made by the artist Wim T. Schippers in honour of Vermeer was unveiled on 31st May 1976. The unveiling should really have taken place at the end of December 1975 to commemorate the third centenary of the artist's death, but it had to be postponed for five months due to all kinds of setbacks. The statue first stood at the corner of the Phoenixstraat and the Schoolstraat, but it was later moved to the Binnenwatersloot. The statue is a stylized symbol of of one of Vermeer's best-known paintings, *The Milkmaid,* which was bought by the Rijksmuseum in Amsterdam in 1908. The work probably belonged to Pieter van Ruijven, later passing to the collection of paintings owned by his son-in-law Jacob Dissius. In the 1696 auction catalogue of Dissius' collection it is called *A Maid pouring Milk* and it is described as being "uytnemende goet" or excellent. The painting has always been much admired and widely known, according to a catalogue of 1719 in which it is called *The famous Milkmaid by Vermeer of Delft.*
The painting is regarded as a simplified version of the Delft kitchen genre which was

very popular in the Netherlands during the sixteenth century, but only continued in the seventeenth century at Delft.

The Milkmaid is the only painting by Vermeer which portrays an ordinary person going about her everyday duties. His other paintings usually depict wealthy ladies and gentlemen at their leisure.

Vermeer used the technique called pointillism in this work, whereby images are built up by means of small dots. This style strives to portray as nearly as possible what the eye sees. The human eye interprets surfaces which catch the sunlight in shady surroundings, as patches and shining dots. This technique was applied especially in depicting the loaf of bread on the table. On the basis of this, the painting is dated about 1658-1660. *The Little Street* and the *View of Delft* were also painted during this period. Vermeer used pointillism in the latter painting to highlight parts with the sun shining on them.

The little statue of *The Milkmaid* is a poor substitute for a Vermeer of its own, which Delft lacks. Most of Vermeer's paintings are in public collections abroad at present. Only the Rijksmuseum in Amsterdam and the Mauritshuis in The Hague have some of his works. It is a bitter thing for Delft to accept that not only have most of the buildings linked with Vermeer disappeared, but the town does not even own a single painting by its most illustrious son.

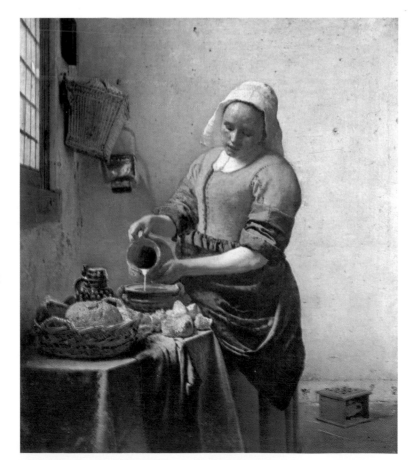

Johannes Vermeer,
The Milkmaid,
c. 1658-1660.
Amsterdam, Rijksmuseum.
This is the only work by
Vermeer which portrays an
ordinary woman absorbed in
her daily duties. The
painting dates from the
period that Vermeer
experimented with the
technique of painting in the
so-called pointillist style.

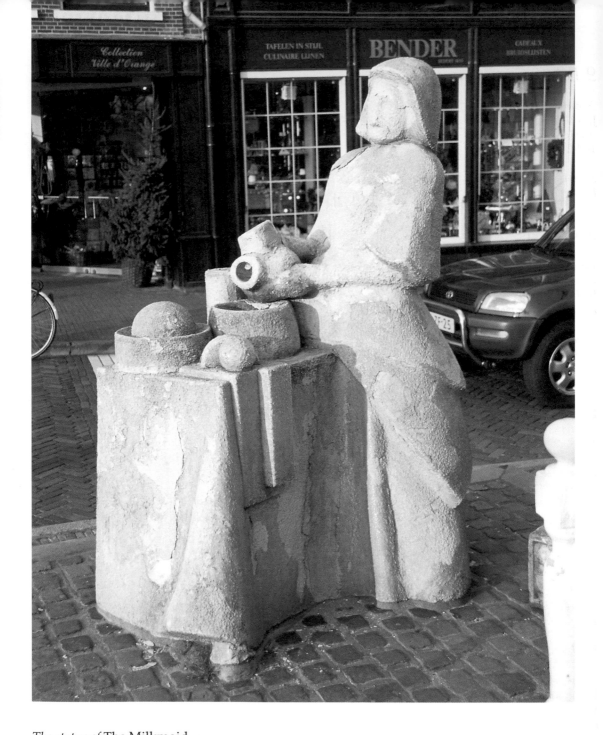

The statue of The Milkmaid.
The artist Wim T. Schippers made the statue of The Milkmaid *to commemorate the third centenary of Vermeer's death. The statue is a stylized portrayal of one of Vermeer's most famous paintings.*

9 Bibliography

Alpatow, M.W., 'Die Straße in Delft von Jan Vermeer', *Studien zur Geschichte der Westeuropäischen Kunst* (Cologne 1974) 142-144 and 193-203.

Alpers, S., *The Art of Describing: Dutch Art in the Seventeenth Century* (Chicago 1983).

Arasse, D., *Vermeer, faith in painting* (Princeton 1994).

Berckel, H.E. van, 'Priesters te Delft en Delfshaven, 1641-1696', in: *Haarlemsche bijdragen, bouwstoffen voor de Geschiedenis van het Bisdom Haarlem* 25 (1900) 230-263.

Berends, G., 'Het Armamentarium tot 1667' in: *De Stad Delft, cultuur en maatschappij van 1572 tot 1667*. Exhibition catalogue Stedelijk Museum Het Prinsenhof (Delft 1981) 51-54.

Beresteyn, E.A. van, *Grafmonumenten en grafzerken in de Oude Kerk te Delft* (Assen 1938).

Berkel, K. van, 'Delft als industriestad in de 17e eeuw' in: *De Stad Delft, cultuur en maatschappij van 1572 tot 1667*. Exhibition catalogue Stedelijk Museum Het Prinsenhof (Delft 1981) 79-90.

Blankert, A., J. M. Montias and G. Aillaud, *Vermeer* (New York 1988).

Blankert, A., 'Vermeers Gezicht op Delft', *Kunstschrift* 38 (1994) 48-49.

Bleyswijck, D. van, *Beschryvinge der Stadt Delft* 2 vols. (Delft 1667-1680).

Bouricius, L.G.N., 'Nog eens 'Het straatje van Vermeer'', *Maandblad van het personeel der verbonden petroleummaatschappijen* 5 (1922) 209-210.

Bredius, A., 'Drie Delftsche Schilders Evert van Aelst, Pieter Jansz van Asch en Adam Pick', *Oud Holland* 6 (1888) 289-298.

Breunesse, J., 'De schilderkunst van ca. 1650 tot ca. 1670' in: *De Stad Delft, cultuur en maatschappij van 1572 tot 1667*. Exhibition catalogue Stedelijk Museum Het Prinsenhof (Delft 1981) 181-190.

Brink Goldsmith, J. ten et al., *Leonaert Bramer 1596-1674. Ingenious painter and draughtsman in Rome and Delft* (Zwolle/Delft 1994).

Broos, B., 'Gezicht op Delft', *Meesterwerken in het Mauritshuis* (The Hague 1987).

Broos, B. et al., *Johannes Vermeer*. Exhibition catalogue National Gallery and Mauritshuis (Washington/The Hague 1995).

Brouwer, H.C., 'Verdwenen kloosters uit de Delftse Binnenstad' in: *De Stad Delft, cultuur en maatschappij tot 1572*. Exhibition catalogue Stedelijk Museum Het Prinsenhof (Delft 1979-1980) 54-59.

Brown, C., *Carel Fabritius. Complete edition with a catalogue raisonné* (Oxford 1981).

Chong, A., *Johannes Vermeer, Gezicht op Delft* (Bloemendaal 1992).

Costaras, N. and J. Wadum, 'Vermeers gerestaureerd. Verseeckert sijn van altijt te duyren', *Natuur & Techniek* 63 (1995) 670-681

Dieleman, A. ed., *Het Barbaraklooster: eene selsaeme geschiedenisse* (Delft 1991).

Ett, H.A., *Het Delftse grachtenboek* (Delft 1975).

Goudappel, C.D., *Delftse Historische Sprokkelingen. Grepen uit de geschiedenis van Delft en omstreken* (Delft 1977).

Gout, M. and M.A. Verschuyl, *Stadhuis Delft* (Delft 1988).

Gout, M. and M.A. Verschuyl, *Nieuwe Kerk Delft en grafmonument van Willem van Oranje* (Delft 1989).

Haaften, C.J. van, *Nieuwe Langendijk: Bouwhistorisch en archeologisch onderzoek van de panden 22 t/m 28* 3 vols. (Delft 1987).

Heijbroek, J.F. and W.Th. Kloek, ''Het straatje' van Vermeer, een geschenk van H.W.A. Deterding', *Bulletin van het Rijksmuseum* 40 (1992) 225-231.

Hengel, F. ten, 'Waag, Vleeshal en Lucasgilde' in: *De Stad Delft, cultuur en maatschappij van 1572 tot 1667*. Exhibition catalogue Stedelijk Museum Het Prinsenhof (Delft 1981) 56-58.

Hoeck, F. van, 'De Jezuieten-Statie te Delft, 1592-1709-1771' in: *Haarlemsche bijdragen, Bouwstoffen voor de Geschiedenis van het Bisdom Haarlem* 60 (1948) 407-444.

Hoogheemraadschap van Delfland 1289-1989. Opstellen ter gelegenheid van een opmerkelijk jubileum (Delft 1989).

Houboult, E., 'Het Straatje', *Maandblad van het personeel der verbonden petroleummaatschappijen* 75 (1924) 66-73.

Kaldenbach, C.J., 'Gezicht op Delft in de 17e en 18e eeuw' in: *De Stad Delft, cultuur en maatschappij van 1667 tot 1813*. Exhibition catalogue Stedelijk Museum Het Prinsenhof (Delft 1982-1983) 132-135.

Kersten, M., 'Jan van Goyens 'Gezicht op Delft vanuit het noorden', 1654', *Delfia Batavorum Jaarboek* (1992) 61-76.

Krogt, P. van der and R. van der Krogt, *Gevelstenen in Delft* (Alphen aan den Rijn 1985).

Kunz, G.G., 'Alsof het hemelgewelf barstte en de aardbodem openscheurde...' in: H.L. Houtzager et al. ed., *Kruit en krijg: Delft als bakermat van het Prins Maurits Laboratorium TNO*. Publication of the Genootschap Delfia Batavorum no. 15 (Amsterdam 1988) 43-52.

Kunz. G.C. and D.P. Oosterbaan, 'Buskruitramp was "straf op de zonden"' in: H.L. Houtzager et al. ed., *Kruit en krijg: Delft als bakermat van het Prins Maurits Laboratorium TNO*. Publication of the Genootschap Delfia Batavorum no. 15 (Amsterdam 1988) 53-64.

Knevel, P., *Burgers in het geweer. De schutterijen in Holland, 1550-1700* (Hilversum 1994). Hollandse Studiën 32.

Lindenburg, M.A., 'Het 'Straatje' van Vermeer', *Delfia Batavorum Jaarboek* (1992) 77-88.

Lutz, E., *Een kerk van honderd jaar, kroniek van een veelbewogen eeuw. Gedenkschrift bij de gelegenheid van het 100 jarig bestaan van de Burgwalkerk te Delft* (Delft 1982).

Maarseveen, M.P. van, *De Compagnie in Delft. Een beschrijving van VOC-locaties in Delft* (Delft 1995). Publication of VVV Delft.

Maarseveen, M.P. van, *In het voetspoor van Vermeer, een wandeling door Delft* (Delft 1995). Publication of VVV Delft.

Maarseveen, M.P. van, *Ach Lieve Tijd, 750 jaar Delft, Delftenaren en de Oranjes* 10 (Zwolle/Delft 1996).

Martin, W., 'Het straatje van Vermeer en de Six-stichting', *Oudheidkundig Jaarboek* 1 (1921) 107-108.

Montias, J.M., *Artists and artisans in Delft, a socio-economic study of the seventeenth century* (Princeton 1982).

Montias, J.M., *Vermeer and his milieu: a web of social history* (Princeton 1989)

Nusselder, E.J., 'Het Oude Mannen- en het Oude Vrouwenhuis' in: *De Stad Delft, cultuur en maatschappij tot 1572*. Exhibition catalogue Stedelijk Museum Het Prinsenhof (Delft 1979-1980) 72-74.

Oosterloo, J.H. *De meesters van Delft* (Amsterdam 1948).

Palm, L.C., 'Antoni van Leeuwenhoek (1632-1723)' in: *De Stad Delft, cultuur en maatschappij van 1667 tot 1813*. Exhibition catalogue Stedelijk Museum Het Prinsenhof (Delft 1982-1983) 96-102.

Peer, A.J.J.M. van, 'Het Straatje van Vermeer', *Gids voor Delft en omstreken* (Delft 1952) 21-25.

Peer, A.J.J.M. van, 'Jan Vermeer van Delft: drie archiefvondsten', *Oud-Holland* 83 (1968) 220-223.

Plomp, M., ''Een merkwaardige verzameling Teekeningen' door Leonaert Bramer', *Oud Holland* 100 (1986) 81-153.

Salomonson, J.W., 'The officers of the White Banner: a civic group portrait by Jacob Willemsz. Delff II', *Simiolus* 18 (1988) 13-62.

Schneider, N., *Jan Vermeer 1632-1675* (Cologne 1994).

Sluijter, E.J., 'De schilderkunst van ca. 1570 tot ca. 1650' in: *De Stad Delft, cultuur en maatschappij van 1572 tot 1667*. Exhibition catalogue Stedelijk Museum Het Prinsenhof (Delft 1981) 172-181.

Sutton, P.C., *Pieter de Hooch, complete edition* (Oxford 1980).

Swillens, P.T.A., *Johannes Vermeer, painter of Delft 1632-1675* (Utrecht 1950).

Temminck Groll, C.L., 'Delft als stad van zestiende-eeuwse woonhuizen' in: *Delftse Studiën* (Assen 1967) 62-114.

Veen, J., 'Boekbespreking', *Oud Holland* 106 (1992) 99-101.

Waals, J. van der, 'In het straatje van Montias, Vermeer in historische context', *Theoretische geschiedenis* 19 (1992) 176-185.

Wadum, J. et al., *Vermeer in het Licht. Conservering, Restauratie en Onderzoek* (Wormer 1994).

Weve, W.F., 'Woonhuizen' in: *De Stad Delft, cultuur en maatschappij tot 1572*. Exhibition catalogue Stedelijk Museum Het Prinsenhof (Delft 1979-1980) 74-80.

Weve, W.F., 'Stadspoorten' in: *De Stad Delft, cultuur en maatschappij tot 1572*. Exhibition catalogue Stedelijk Museum Het Prinsenhof (Delft 1979-1980) 80-84.

Weve, W.F., 'Delftse woonhuizen' in: *De Stad Delft, cultuur en maatschappij van 1572 tot 1667*. Exhibition catalogue Stedelijk Museum Het Prinsenhof (Delft 1981) 60-62.

Weve, W.F., 'Verdedigingswerken' in: *De Stad Delft, cultuur en maatschappij van 1572 tot 1667*. Exhibition catalogue Stedelijk Museum Het Prinsenhof (Delft 1981) 62-65.

Weve, W.F., *Voorlopig rapport betreffende de panden Nieuwe Langendijk 22 t/m 26 als onderwerp van het schilderij 'het straatje' van Johannes Vermeer* (Delft 1982).

Wheelock, A.K., *Jan Vermeer* (New York 1981).

Wheelock, A.K. and C.J. Kaldenbach, 'Vermeer's *View of Delft* and his vision of reality', *Artibus et historiae* 6 (1982) 9-35.

Wheelock, A.K., 'History, Politics and the Portrait of a City: Vermeer's *View of Delft*' in: S. Zimmerman and R.F.E. Weissman ed., *Urban Life in the Renaissance* (Newark 1989) 165-184.

Wheelock, A.K., *Vermeer and the Art of Painting* (New Haven/London 1995).

Wijbenga, D., *De Oude Kerk van Delft, 750 jaar in woord en beeld* (Delft 1990).

Wright, C., *Vermeer* (London 1976).